CIRCA 1600

CIRCA 1600

A Revolution of Style in Italian Painting

S. J. Freedberg

THE BELKNAP PRESS OF HARVARD UNIVERSITY PRESS
Cambridge, Massachusetts, and London, England

10 9 8 7 6 5 4

Library of Congress Cataloging in Publication Data

Freedberg, S. J. (Sydney Joseph), 1914–
 Circa 1600: a revolution of style in Italian painting.

 Three lectures given at Cornell University in May 1980.
 Bibliography: p.
 Includes index.
 1. Carracci, Annibale, 1560–1609. 2. Carracci,
Lodovico, 1555–1619. 3. Caravaggio, Michelangelo
Merisi da, 1573–1610. 4. Mannerism (Art)—Italy.
I. Title.
ND623.C38F7 759.5 82-1076
ISBN 0-674-13156-8 (cloth) AACR2
ISBN 0-674-13157-6 (paper)

Preface

THE THREE LECTURES presented in this book were given at Cornell University in May 1980 under the auspices of the Preston H. Thomas Memorial Lecture Series, sponsored by the College of Architecture, Art & Planning, Cornell University. The lectures on Annibale and Ludovico Carracci are printed here as they were given, with only very minor editorial amendment. The Caravaggio lecture, delivered from extensive notes rather than a finished text, has here assumed a more polished form.

My preserving the original lecture form is a considered choice, first because I believe that it is historically appropriate that the printed volume of a lecture series preserve as much as possible the event from which it came and which it purports to record; more important, the lecture form, which permits a maximum liberty of illustration, encourages a range and specificity of observation that a study written as an essay tends to limit or deny. The lecture form suits me particularly, since what I say about these artists derives almost altogether from my confrontation with the visual substance of their art. The publishers have recognized the essential role the illustrations played in the lectures and have virtually duplicated their original abundance. I hope the reader now may find that I have turned back on the illustrations some part of the illumination my study of the pictures has conveyed to me.

Because no lecturer can hope that his audience will remain unchanged throughout a series, I felt it necessary, very summarily, occasionally to rehearse a point that I had touched on in a previous lecture. It may be an excess of historical conscience to retain these few places here, but they are surely not enough to bore or give offense.

For the reader who may be interested in pursuing this subject further, I have appended a restricted bibiliography of writings available in English.

I am obliged to friends who gave invaluable help in securing photographs for reproduction: Dr. Bernice Davidson, Mrs. Karen Einaudi, Professor Andrea Emiliani, Professor Kathleen Weil Garris, Laura Giles, Professor Donald Posner, M. Pierre Rosenberg, Mr. Alan Salz, and Mrs. Christine Lilly of the Fine Arts Library in the Fogg Museum. Miss Marilyn Perry, Executive Vice President of the Samuel H. Kress Foundation, responded quickly and generously to a request for assistance from the Foundation that has allowed the book its color illustrations. I am especially grateful to her. Mrs. Maud Wilcox has once again made me feel welcome and at home at Harvard University Press, as has my editor, Ms. Katarina Rice, with whom it has been a rare satisfaction to have worked.

I must express my great thanks to Professor Colin Roe, whose interest brought these lectures into being, and to the Thomas family, whose generous sponsorship of the Preston Thomas Lectures gave them their public forum.

Contents

I

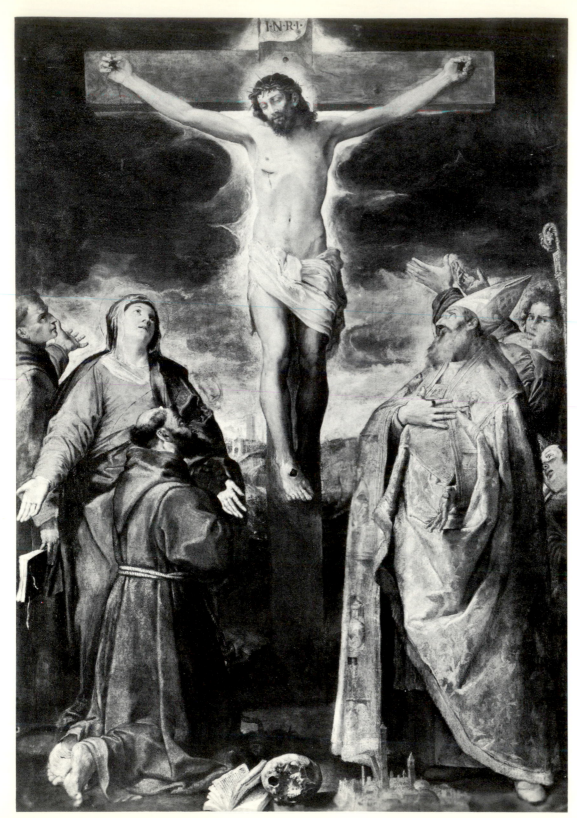

PLATE I.
Annibale Carracci,
Crucifixion with Saints.
Bologna, S. M. della Carità

ANNIBALE CARRACCI

A BRIEF AND EFFECTIVE WAY to understand the nature of the change that the three artists of the Carracci family—Ludovico, the oldest, and his cousins Agostino and Annibale (the last one most decisively of all)—wrought in their contemporary art is to see what that art seemed like to the generation that followed the Carracci, for whom the revolution that Annibale principally made had come to have canonical authority. Count Carlo Cesare Malvasia, writing in the mid-seventeenth century in his *Felsina Pittrice,* described the context of art before and close to the time of the Carracci thus: the followers of the great masters of the various Italian schools had at that time departed from their models, and "seeking another style and a different way of doing, fell into a weakness of drawing, not to say an incorrectness of it, into a flaccid and washed-out coloring, in sum into a certain manner [*maniera*] far from verisimilitude, not to mention from the truth itself, totally chimerical and ideal . . . these were Salviati (1), the Zuccari (2), Vasari (3), Andrea Vicentino, Tommaso Laureti, and among our painters in Bologna Sammachino (4), Sabbatini (5), Calvaert, Procaccini (6), and their like, who, abandoning the imitation of antique statuary, as well as of nature, founded their art wholly in their imagination, and worked in a careless and mannered way."

Let us see how Annibale Carracci's great alteration in the history of Italian art began. Its first public act was the setting up in 1583 of an altar painting of a *Crucifixion with Saints* (plate I) in the Bolognese church of S. Niccolò (now transferred to the church of S. M. della Carità); when it was unveiled it brought down on Annibale, its author, the censure of all his Bolognese Maniera colleagues. This is not a historical picture of the Crucifixion; its iconography defines it as a devotional and symbolic image of the event. But there is nothing whatever symbolic in its mode of representation. The scene conveys an instant effect of reality:

1.
Francesco Salviati,
Caritas.
Florence,
Uffizi Gallery

persons who seem utterly ordinary, the nude Christ not excluded, are described to us with means that remarkably suggest the truth of their existence—heavy figures revealed by a power of light within a space, who convince us still more that they reproduce an ordinary truth because they have abjured altogether the effects of artifice, in appearance and in mode of action or expression, that were hitherto traditional to art and, among the contemporary Mannerists, were its prime currency. Never before this within the sixteenth century had an image been created with so minimal an intrusion of the processes of idealization, with such avoidance of the means of rhetoric, or with so blunt a confrontation with the simple truth.

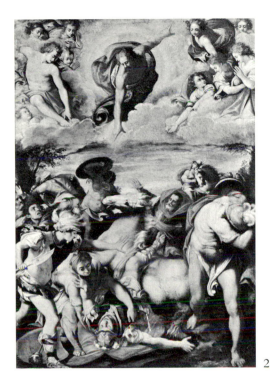

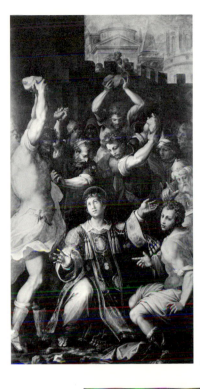

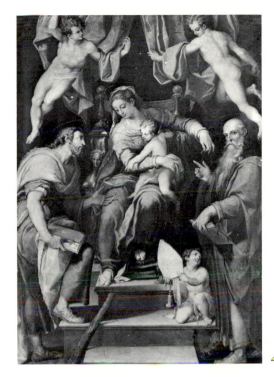

2.

3.

4.

2.
Taddeo Zuccaro, *Conversion of St. Paul.*
Rome, Doria Gallery

3.
Giorgio Vasari, *Stoning of St. Stephen.*
Vatican Gallery

4.
Orazio Sammachini, *Madonna Enthroned
with Saints.* Bologna, S. M. Maggiore

5.
Lorenzo Sabbatini and Dionisio Calvaert,
Holy Family with St. Michael.
Bologna, S. Giacomo Maggiore

6.
Ercole Procaccini, *Conversion of St. Paul.*
Bologna, S. Giacomo Maggiore

5.

6.

The extraordinary novelty that is in this altarpiece may be related to tendencies of difference with the then reigning style of Mannerism that had manifested themselves in the years close to the moment of creation of this picture, but these are, most often, no more than tendencies, appearing only sporadically, and then in fragmentary elements only of a work of painting: the interpretation of the theme of a symbolic *Crucifixion* by Annibale's older colleague among the artists of Bologna, Bartolommeo Passarotti, about 1575 (the picture, destroyed in World War II, was formerly in the Bolognese church of S. Giuseppe; 7), is typical in its intrusion of some incidents of sharply literal description, as in the faces and in parts of the anatomy, into an evidently artificial whole. More rarely, in Florence particularly and to a lesser degree in Rome, there were some artists whose intention it was to reform the extravagances of contemporary Mannerism and make images which should more consistently assert an unornamented clarity of form and simple legibility of content.★ Such, for example, is the character of the early works of a painter working in this reforming mode in Rome, Scipione Pulzone, in his *Assumption of the Virgin* (Rome, S. Silvestro al Quirinale,

7.
Bartolommeo Passarotti, *Crucifixion with Saints*.
Formerly Bologna, S. Giuseppe (destroyed in World War II)

★ It may be helpful to the reader to define the usage of the terms "Mannerism" and "Maniera," in both their upper- and lower-case forms, which apply to the styles of art that prevailed in Italy until the events described here. Lower-case *maniera* is, simply, the Italian word for "manner" or "style." In the art of the middle years of the sixteenth century in Italy, in Central and Northern Italy in particular, the notion of style became a matter of self-conscious stress, achieving an artificial, indeed often mannered, stylishness. Upper-case "Maniera" describes the collective character of art of this kind and also denotes the period itself.

Lower-case "mannerism" refers to art which has traits similar to those displayed in the Maniera but which may appear in other periods as well. Upper-case "Mannerism," however, applies only to the sixteenth century and includes not only the fully achieved art of the Maniera but the prior developments, succeeding the classical style of the High Renaissance, out of which Maniera came, as well as many resembling but by no means identical modes of artistic practice throughout Italy from the second quarter of the sixteenth century to its end.

1585; 8), or, more legibly, of the pictures of the prime Florentine reformer, Santi di Tito, as in his *Crucifixion* (Florence, S. Croce; 9) of 1588. But it requires only the briefest confrontation for us to see that the near-contemporary pictures of a Pulzone or a Santi are still, despite the quota they may show of naturalism, bound to a mentality of idealization and convey more sense of an accomplishment of art than they do of the sense of a reality. The works of these contemporary painters may constitute a reform of style, but by contrast Annibale's *Crucifixion* has achieved a revolution.

It is proper to inquire for native forces that might have generated this remarkable event in the young Annibale's art. What would at first seem to be one of them offers itself in the immediate time and place of the *Crucifixion* of 1583. At the end of 1581 and into 1582, Cardinal Gabriele Paleotti, archbishop of Bologna, a distinguished and admired reforming churchman, had circulated among a limited group of intellectuals and clergy, mainly within Bologna, two chapters of a treatise on art, called *Discorso intorno alle imagini sacre e profane,* together with an outline of the three further chapters he proposed to write but never did. The segment of Paleotti's *Discorso* was printed but not in any normal sense "published"; it was circulated to solicit criticism and comment.

Much of the content of the *Discorso* is conventional and Counter-Reformational in tenor, but there are also in it views on the nature and role of art that at this moment

8.
Scipione Pulzone,
Assumption of the Virgin.
Rome, S. Silvestro al Quirinale

9.
Santi di Tito, *Crucifixion.*
Florence, S. Croce

8.

9.

seem a novelty. Conspicuous among them, for our purposes, are an appreciation of the imitation of nature in art and of the power of art to achieve direct and emotionally affecting communication. We know enough about the distribution of the *Discourse,* both just before and after the date of its partial printing, to think it likely that Annibale, as well as his brother Agostino and his cousin Ludovico, might have had access to it, or at least knowledge of its contents indirectly. Could Paleotti's endorsement of an affective naturalism in art have been the causal agent of Annibale's new style?

This proposition, in my estimation, most likely yields a negative response. Paleotti's statements are insufficiently concrete to serve as guidelines for an artist's style, and they are made in a tone that is more declarative than hortatory. It is almost a psychological impossibility that Paleotti should have formulated in his mind a goal of style like the one Annibale in fact achieved, and that, in the years when the *Discorso* was being written, in the mid-1570s, the cardinal's visual imagination should have exceeded the sum of his experience of art as he knew it then, well before the *Crucifixion* altar happened. Paleotti's sense of what art ought to be could reasonably be expected to have been aligned with the avant-garde of the mid-1570s—that is, with the earliest manifestations of the Reform movement, which I have sketchily described—but not to have outstripped it. That this was in fact the case is proved by Paleotti's own patronage, which went not to Annibale or even to Ludovico Carracci (who, as we shall see later, should have been more directly sympathetic to him), but to Bartolommeo Cesi (10), whose manner was at best a very approximate counterpart, and partly a reflection, of that of the Florentine reformer Santi di Tito, and who came in time, about a decade after the S. Niccolò *Crucifixion,* tentatively to accept some of the advanced ideas of the Carracci. The writings of Paleotti could not have been a *causa efficiens* for Annibale's revolutionary act of style;

however, they could still have served as a kind of precipitate for it, for they fell on fallow ground—an inclination in Annibale to confront ordinary reality and to imitate its look that was manifest before the *Crucifixion* and was demonstrated in areas of art to which Paleotti's doctrine was not addressed or which were even contradictory to it.

There is signal evidence in Annibale's remarkable *Dead Christ* (11), now in Stuttgart, dated universally by art historians in 1582. The subject is religious, but it seems quite evident that the religious meaning of the image is not its primary one and may be no more than a pretext. The main sense that the work conveys is of its ingenuity as a realistic study of an unidealized anatomy set arbitrarily, in a tour de force that obviously recollects the fifteenth-century painting of Mantegna, in an illusionist perspective. The mentality of the conception, contradictory to the pretext of subject matter, is that of a still-life painting or a piece of genre.

10.
Bartolommeo Cesi,
Annunciation.
New York,
private collection

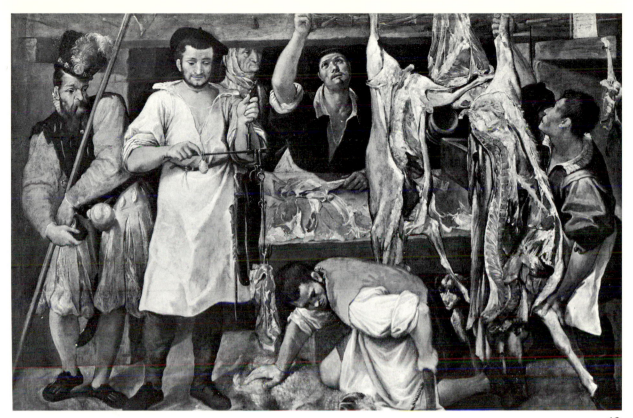

11.
Annibale Carracci,
Dead Christ.
Stuttgart, Gallery

12.
Annibale Carracci
Butcher's Shop.
Oxford,
Christ Church Gallery

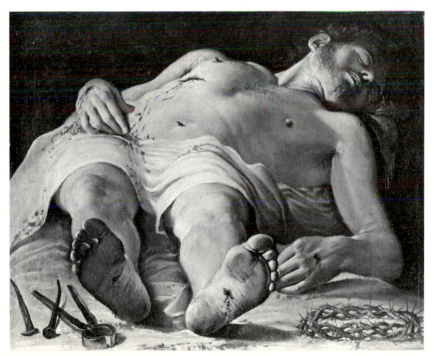

[7]

That the painter's first probings for reality are through the subject-instrument of genre is confirmed by a much larger and more ambitious work, explicitly a scene of genre, the *Butcher's Shop* (Oxford, Christ Church Gallery; 12), of the same year or at the latest early 1583. It serves to identify the region in which Annibale's inclination to such reality in genre started: within the school of Bologna, in the models of comparable subject matter in the art of his older, still Mannerist compatriot, Bartolommeo Passarotti (as for example in the National Gallery in Rome, ca. 1575; 13), which took their impetus in turn from genre works, realistic in detail but in whole stylistic substance Mannerist, imported into Italy from sixteenth-century Flanders, as in the work of Joachim Beuckelaer. Almost surely still in 1583, three versions of the theme of a *Boy Drinking* (one of them at London, Art Market; 14), are directed to the most ordinary and intimate of human actions, and compound the wish to illustrate a common human fact with a remarkable effect of still-life illusion: to achieve this end Annibale experiments with a technique—a mode of summary and textural brushwork—that makes equivalence in paint for the optical sensations by which we apprehend appearances. A moment later, in 1583 or 1584, the *Bean Eater* (Rome, Galleria Colonna; 15), far more daring and assertive than the *Boy Drinking*, employs a more developed version of this optical technique to put us into forceful and immediate confrontation with this peasant presence, with the effect of an intrusion by us into his actuality, where we are neither welcome nor expected.

The vocabulary of the S. Niccolò *Crucifixion* was, thus, present in Annibale's art before that painting; it came into the altarpiece from a vocabulary he had developed in the realm of genre, which more appropriately had summoned forth from him an interest in the depiction of reality and the pictorial means by which it might be achieved. Genre must not be taken as a cause for Annibale's new naturalism, however, but as an opening to it and a vehicle for exploring it.

Phenomena of style within an artist's work must not be measured by a rigid yardstick: within a style we must apply the concept of modality, by which the manner of employing basic elements of a style may be altered, often with considerable flexibility, to accord with the artist's sense of the nature of his subject. The decoration that Annibale undertook together with his cousin and his brother in the Palazzo Fava in Bologna in the same year as the *Crucifixion* of S. Niccolò (the work continued into 1584) began with a mythology, the story of Europa, painted in a frieze in the smaller one of two adjoining rooms; the larger room was painted with a frieze of a more serious ancient tale, a mythology which pretends to the character of a history,

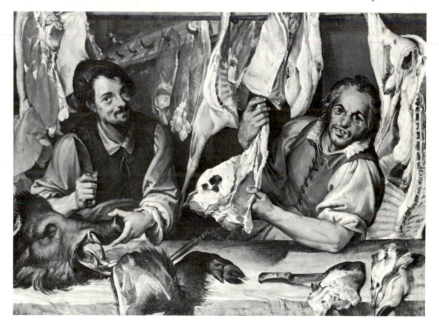

13.
Bartolommeo Passarotti, *Butcher's Shop*.
Rome, National Gallery (Palazzo Barberini)

14.
Annibale Carracci,
Boy Drinking.
London, Art Market

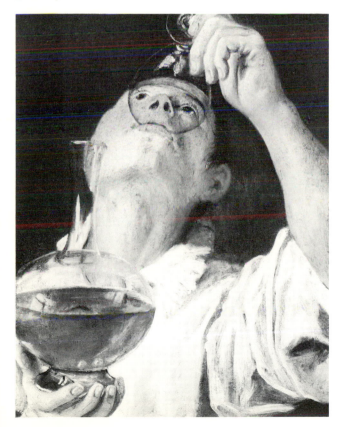

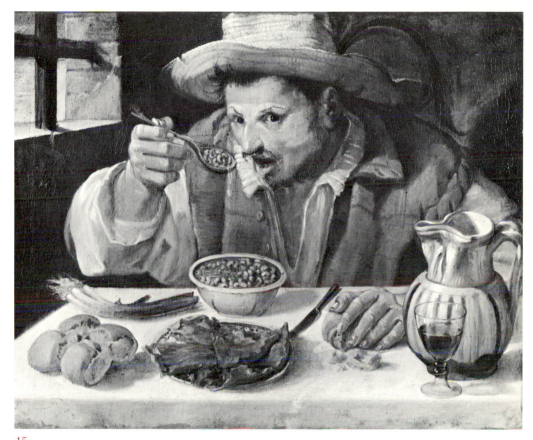

15.
Annibale Carracci, *Bean Eater*.
Rome, Colonna Gallery

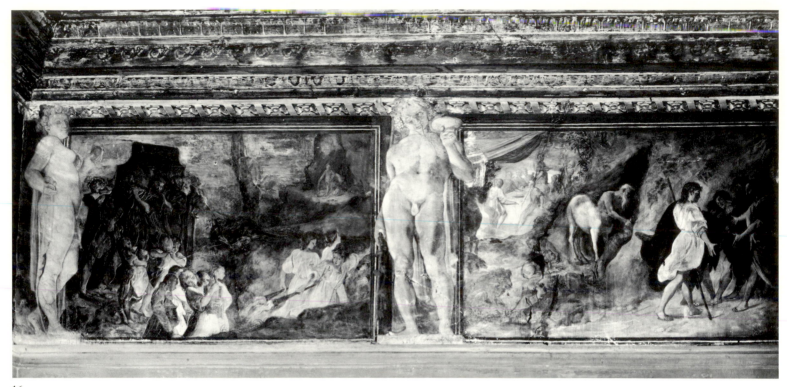

16.
The Carracci, *Frieze with the History of Jason,* part.
Bologna, Palazzo Fava, Sala di Jasone

that of Jason (16). There is no place in this pagan world for the sobriety and bluntness that Annibale had found for the *Crucifixion:* no less effectively natural than the religious picture, these works seek a different mode, and the modality is further distinguished between the purely mythological story of Europa and the Jason story that asserts it is a history.

There can be no better way of showing what the novelty of Annibale's style is, beneath its modal inflections, than a comparison of his depiction of *Europa Mounting the Jovian Bull* (17) with Veronese's interpretation of the same theme (18), painted in the Palazzo Ducale in Venice only a half-dozen years before. The formality of the Veronese, posed and artificial, is replaced in Annibale's picture by a seeming utter casualness. Veronese's careful suavities give way to a loose-limbed, loose-jointed grace of design, whose movement seems not to be imposed as pattern on the composition but to be instead a byproduct of the figures' natural, unposed actions; and as they open to the landscape, it no less than they makes up the picture's fabric. Barely idealized in appearance and in attitude, the actors exist within an environment of air and space that conveys the freshness

17.
Annibale Carracci, *Europa Mounting the Bull*,
Bologna, Palazzo Fava, Sala di Europa

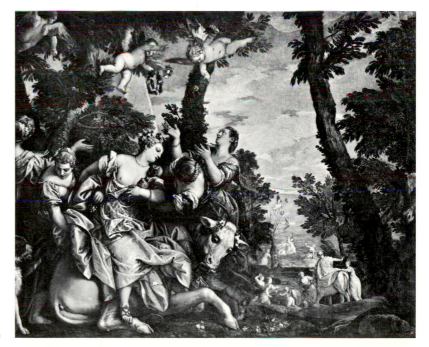

18.
Paolo Veronese, *Europa Mounting the Bull*.
Venice, Palazzo Ducale, Sala del Anticollegio

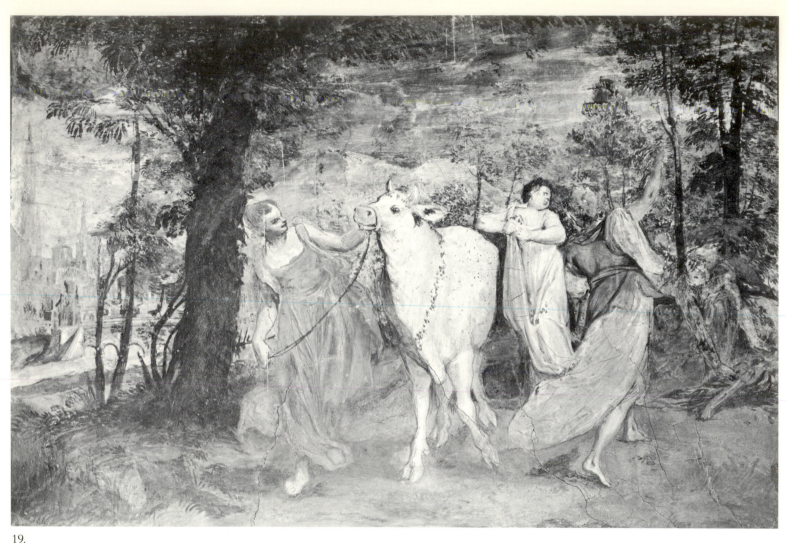

19.
Annibale Carracci, *Europa Leading the Bull*.
Bologna, Palazzo Fava, Sala di Europa

of a day in spring, and the whole effect the image creates is of an instant verisimilitude. Another scene in the Europa story, *Europa Leading the Bull* (19), exerts a charm of truth that may be still more persuasive in the finely observed naturalness with which Annibale has characterized the movement of the animal as well as of the maidens: their grace is adulterated with a small, sympathetically seen, and slightly funny touch of common awkwardness.

I have remarked that the modality in Annibale's conception of the scenes he painted in the Jason frieze is different from that in the Europa room. The—as I have called it—"historical" nature of the content of the Jason story asks for more formality of design, and even a certain rhetoric of expression; and the large dimension of the space of this room, refusing intimacy, would in itself suggest this. Just such qualities are at once perceptible in the Jason frieze by

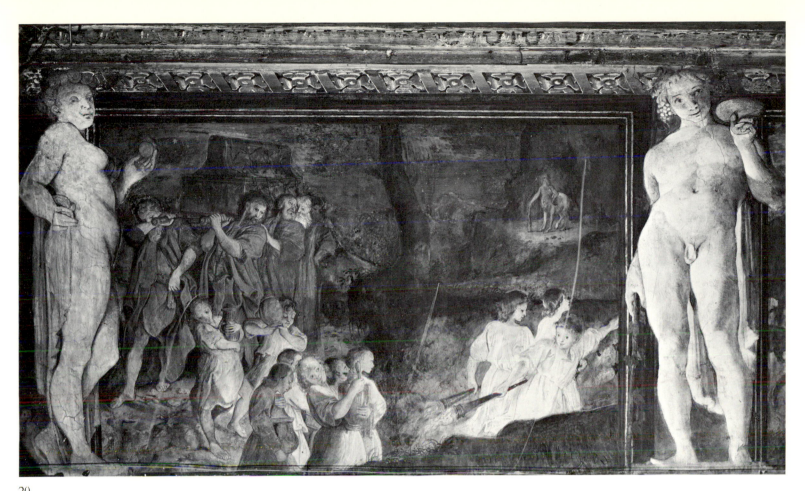

20.
Annibale Carracci, *False Funeral of the Infant Jason*.
Bologna, Palazzo Fava, Sala di Jasone

comparison with that in the Camerino d'Europa. The *False Funeral of the Infant Jason* (20) illustrates them: the attitudes of the figures have a distinct measure of styled deliberation, calculated to be decorative in effect and in some places also rhetorical; the composition retains almost no part of the casualness of the Europa scenes, but is arranged on an explicit and sequential armature, whose rhythmic movement extends that of the figures. There seems to be in such a scheme as this at least a partial readmission into Annibale's aesthetic of some ideas of the Maniera, and this is confirmed when we observe the way in which he has rhythmically manipulated the shapes of the anatomies. Yet so powerful is the essential novelty of Annibale's style—his naturalism—that these inflections only qualify it; they cannot compromise it. Physical existences are defined with entire conviction by a varied and wonderfully nuanced light, and psychological responses are characterized with a subtlety and liveness that are new in Annibale in this degree. Another scene, the *Battle in the Libyan Desert with Wild Beasts and Harpies* (21), conveys another new dimension of Annibale's power to evoke reality in the way in which the fighting men—the Herculean figure in the foreground in

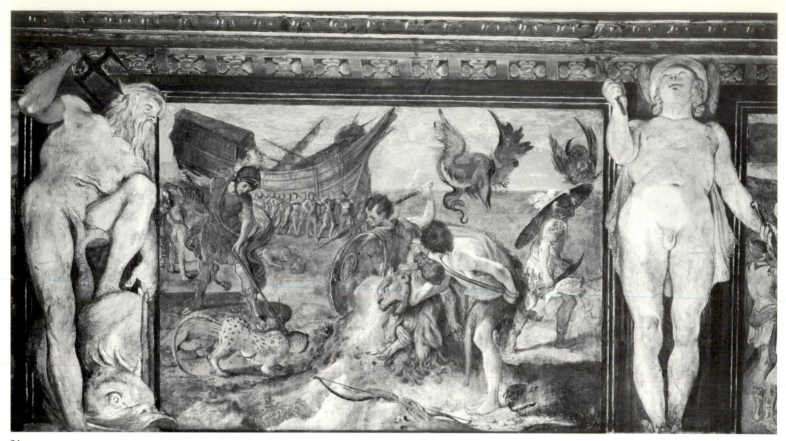

21.
Annibale Carracci, *Battle in the Libyan Desert
with Wild Beasts and Harpies*.
Bologna, Palazzo Fava, Sala di Jasone

particular (22)—demonstrate credible anatomies inhabited by an energy that, as the Hercules conspicuously displays it, radiates into the surrounding atmosphere.

The *Allegory of Truth and Time* in Hampton Court (23) closely succeeds the painting of the Jason frieze. Contemporary viewers would have seen in it not only an allegory but a *poesia,* a kind of subject matter for which not only Paleotti's *Discorso* but other Counter-Reformation tracts held flexible standards, allowing liberties in appearance and expression of the kind customary to Maniera. Here Annibale has again sought an appropriate modality, and he has readmitted from the repertory of Maniera, more than in

the Jason histories, ornamental values in design and a consonant poetic mode of feeling. But these readmitted qualities of Mannerism do not exist as overlays or as intrusions in the *Allegory;* they have been fused absolutely with Annibale's newly invented naturalism—into substances more sensuously assertive than in any preceding work, into surfaces more variously luminous and textured, while the rhythms that make ornament have been infused with the strongest pulse of energy.

The revelation of so sensuous a physicality, so subtly and elegantly manipulated in the *Allegory,* is not in Annibale's native vein but is rather a response to his experience

[14]

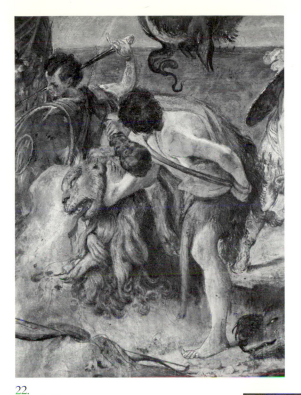

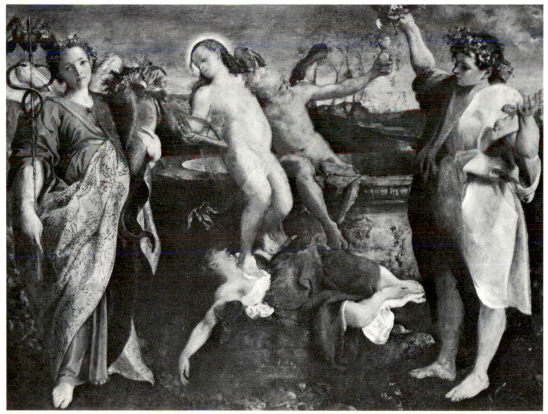

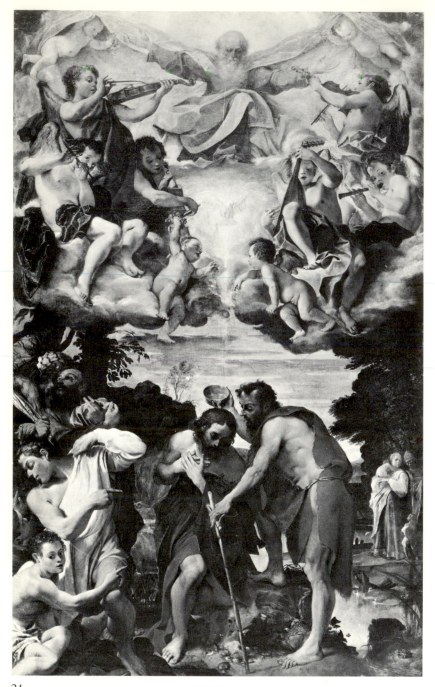

24.
Annibale Carracci, *Baptism of Christ*.
Bologna, S. Gregorio

of Correggio. This is the likely first in a long series, essential to Annibale's history, of creative exploitations of past art that would simultaneously promote his progress in new directions and bind him to the mainstream of continuity with the artistic past. The process is more obviously documented in Annibale's *Baptism of Christ* (24) in the Bolognese church of S. Gregorio, which though commissioned in 1583 was not executed until the date it bears, 1585. The dependence on Correggio's models is explicit: on the motifs of his cupola in Parma (25), and not only on the altarpieces that were then in Parma but on the vocabulary, touched with Mannerism, of Correggio's *Madonna of St. Sebastian* (26), then in Modena. Annibale's adaptation of the motifs signifies less, however, than his response to Correggio's handling of surface, a *sfumato* that makes presence seem as if it should be palpable, and which inspires in flesh a quasi-erotic magnetism, appealing to the visually experienced quality of touch. Annibale's figures remain, however, more earthbound than Correggio's, affirming their actuality of substance, and it is this weighing physicality of Annibale's persons that moderates a borrowed Correggesque temper of complex excitement in the whole design.

It is not only a modality but, beyond it, a measurable alteration of style that shapes the *Pietà with Saints* (Parma, Gallery; 27) of 1585: most immediately and visibly the residues of Maniera in the presentation of the forms have been very much diminished or almost altogether eliminated; though in terms that are more complex and sophisticated than in the S. Niccolò *Crucifixion,* this is a reprise of that modality. Correggio's model (28) is operative on the creation of this image, painted for Parma, in multiple ways, but—beyond the evident adaptations of motifs and elements of design—the most important may be the way in which the naturalism of representation has been passed, as

25.
Correggio, *Assumption
of the Virgin,* detail.
Parma, Duomo

26.
Correggio,
Madonna of St. Sebastian.
Dresden, Gallery

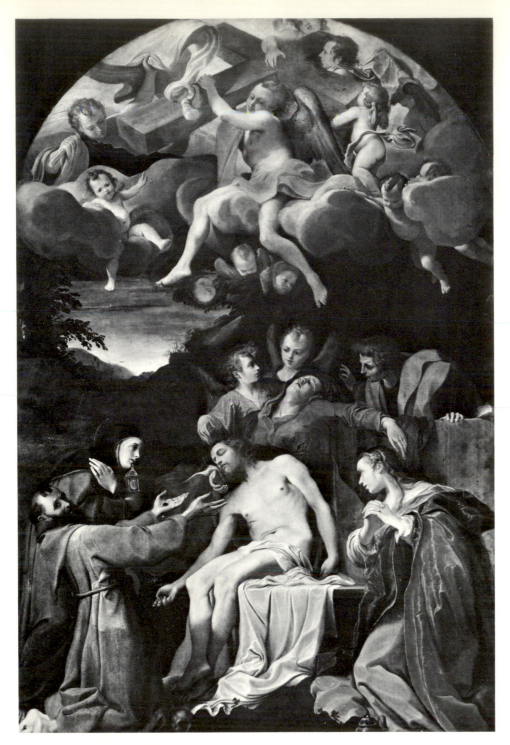

27.
Annibale Carracci,
Pietà with Saints.
Parma, Gallery

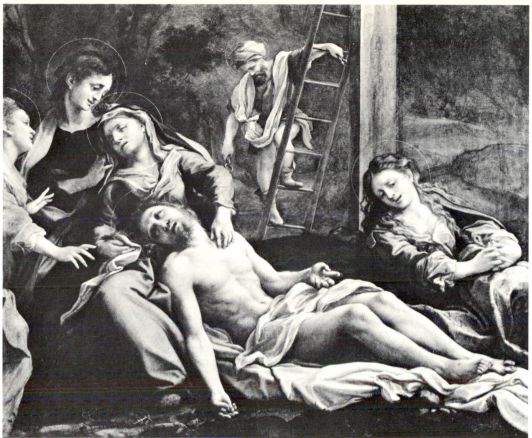

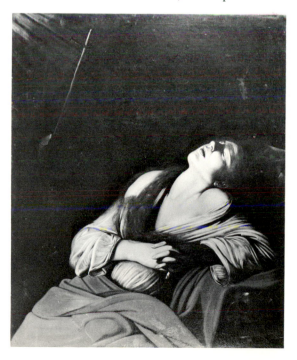

it were, through a Correggesque sieve of moderating ideality, to come out at once sharpened in precision and in effect of existential truth. The naturalism is, as well, more controlled, referent even as it intensifies effects of truth to a beauty that derives from ideality.

I wish to intrude here an observation that concerns a subject I shall treat of later. When one observes the *Repentant Magdalen* of Caravaggio (29)—which survives to us only in the form of copies—in connection with Annibale's *Pietà,* it would appear that Caravaggio based his conception of his theme on a memory of Annibale's swooning Virgin. Caravaggio must, therefore, have come to know the early and revolutionary works of Annibale Carracci on Caravaggio's way to Rome, presumably in 1592, *before*

quality of the image become less earthbound, touched with the ideal, appropriately distancing itself from us.

There is another major novelty of effect—the infusion of these densely material substances with an energy that not only expands beyond the limits of their forms into their immediate context of space and atmosphere but is of such power as to convince us that even these densities can be levitated by this energy and propelled through space, as the Virgin is; the energy here expressed by forms transcends not only their limits but the limits of the picture. This is different from Titian, the splendid energy of whose images is always internal to the picture. It is different also from Correggio, in whose paintings energy can be vibrant and expansive beyond the limits of the work of art, pervasive beyond anything in Annibale, but does not carry weight: no matter how sensuously palpable Correggio's figures may seem to be, it is an optical "realization" of them that we perceive; there is not an apprehension, as in Annibale, of a substance and a mass. This distinction is a vital one, for it separates Correggio's proto-baroque from Annibale's achievement, for the first time in the *Assunta*, of the bases of a genuine Baroque—no longer a proto-baroque—style.

Hardly had this remarkable affirmation of a new style been accomplished when a moderating impulse was imposed upon its aggressiveness and novelty, as if Annibale should have doubted his own daring. The moderating impulse is the result again of the new Venetian experience, in part from the classicizing example of Titian, but more pressingly from that of Veronese (33), less essentially classical and rather the practitioner of a cosmetically refined but brilliantly existential description. Veronese's descriptive efficiency appealed inevitably to Annibale, and his facile beautifying of form was an easily accessible counterweight to the too assertive naturalism from which, once achieved in the Dresden *Assunta,* Annibale thought better

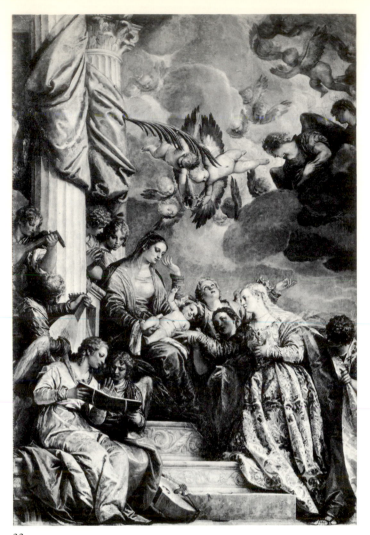

33.
Paolo Veronese, *Marriage of
St. Catherine*. Venice, Academy

to withdraw. The *Madonna of St. Matthew* of 1588 (also in Dresden; 34) is a demonstration of Annibale's retreat from a position that may have seemed polemical—achieved, we must remember, in only four years since his first public work in S. Niccolò—and of compromise with the chronologically very near perpetuation in Venetian art of the classical ideal. (Veronese, we must recall, died only in this year.) The measure of change from the ambitions of the

34.
Annibale Carracci,
Madonna of St. Matthew.
Dresden, Gallery

35.
Annibale Carracci, *S. Ludovico Altar*.
Bologna, Gallery

Assunta is considerable: not just of a modality determined by the devotional, as contrasted to the *Assunta's* dramatic, subject but, more essential, achieving a tonality of expression and a mode of order not unlike that in Veronese and a moderating ideality of forms and appearances that in principle at least resembles his. But no matter how deliberate Annibale's Veronesian restraints may be, the visual and plastic actuality of presence that Annibale has conquered for art in a new degree informs the mechanisms of restraint, and the painting is, in its differently controlled way, only a little less commanding an affirmation of actuality than the *Assunta*.

Annibale's was too keen and too undogmatic an intelligence to be bound, in this still early stage of his development, to a fixed and single credo. What he was dealing with was, after all, ideas of his own invention, or the ideas of prior great painters that he had recreated to his own ends. In the years immediately succeeding the Dresden *Assunta* and the *St. Matthew* altar each of the distinct tendencies we saw in them, and which we may now properly term respectively a baroque tendency and a classicizing one, were manifest in Annibale's art; the baroque dominant, but altered, partly in its superficial complexion and partly in its essence, by elements of classicizing kind. The *S. Ludovico Altar* (Bologna, Gallery; 35), of which the most likely date is 1589–90, is conceived upon a scheme of contrapuntal orderings of form, grave in substance and of a slow dignity in movement, that suggest antecedents from the classical High Renaissance such as the works of Fra Bartolommeo, which Annibale is not likely to have known; or, given the picture's chiaroscuro and textural opulence, some monumental altar scheme of Titian's (such as the *S. Niccolò Altar* in the Vatican; 36). Still more than the antecedent *Matthew* altar this one demonstrates the proposition, vital to Annibale's future art, that the conviction inspired in the spectator of the truth of the

36.
Titian, *S. Niccolò Altar.*
Vatican Gallery

37.
Annibale Carracci,
S. Ludovico Altar, detail.
Parma, Gallery

[25]

existence that the artist paints depends not on literal mimesis or such a recreation in paint of ordinary reality as is in the Apostles of the *Assunta* but on the recreation with the painter's brush and color of those optical sensations through which we visually apprehend the world (37). These optical effects that denote substances existing in a complexly lit, atmospheric space, which Annibale deduced first from Correggio and then, as in this painting, significantly reinforced from Titian, have here been applied with such convincing effect that Annibale no longer needs to call upon devices of literal descriptive truth: the *popolano* types and the repertory of genre are not now required, and Annibale may readmit from the vocabulary of the sixteenth century's classical tradition notions of ideality of feature and expression in the countenance, of harmony and plenitude of shape of body, of deliberated, rhythmed grace in attitude and gesture, and of suavities of managed drapery. Yet none of this artifice, here so beautifully accomplished and so calculatedly beautiful in effect, diminishes the power of verisimilitude that is in the whole image; it only demonstrates that the existence it so convincingly describes is of a higher order. It is this existential power that, despite the accumulation in this altar of classicizing idea and device, affirms that its style is not retrospective, but in its essence of the new way of Annibale's so recent invention.

In the *St. Luke Altar* (Paris, Louvre; 38), dated 1592, the classicizing ideality of appearances and attitudes is in some ways still more apparent: the rhetoric of posture in the Luke seems magnified from what we might find in a Titian or a Raphael. Yet, to contrast this painting with the work of Raphael that could just possibly have inspired it (remember that the *Sistine Madonna* (39) was at that time in Piacenza, in North Italy, not far from Annibale's native Bologna) is to realize how the classical elements of Annibale's painting are an inflection of its meaning rather than

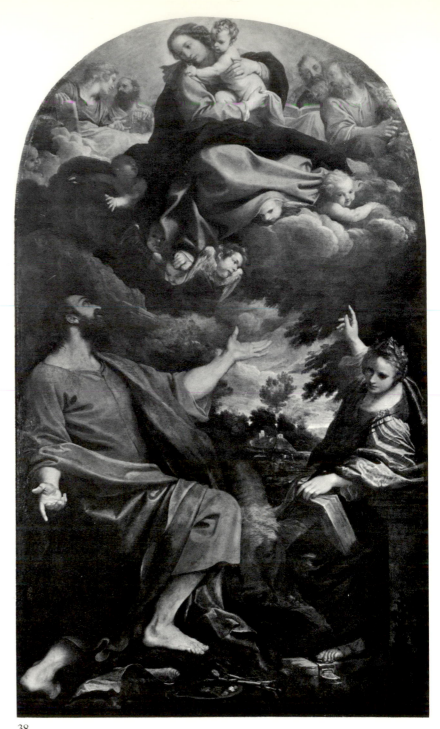

38.
Annibale Carracci, *St. Luke Altar*. Paris, Louvre

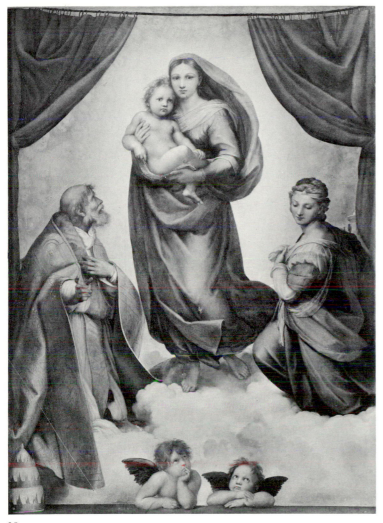

39.
Raphael,
Sistine Madonna.
Dresden, Gallery

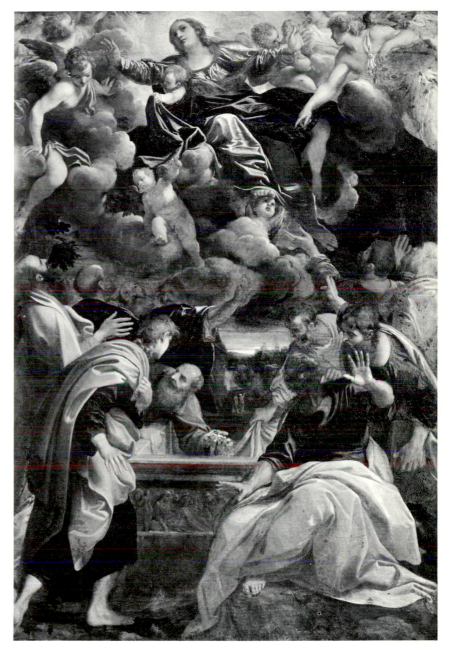

40.
Annibale Carracci,
Assumption of the Virgin.
Bologna, Gallery

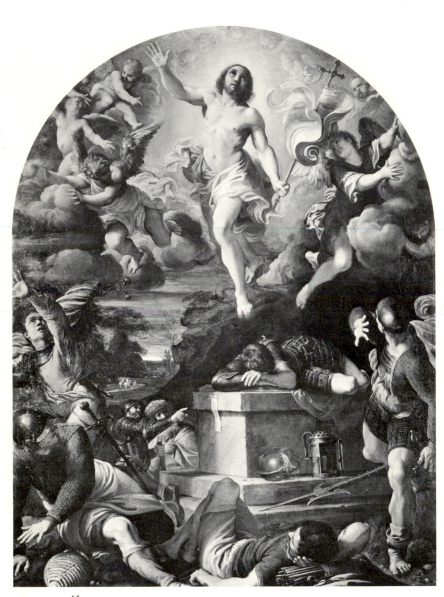

41.
Annibale Carracci, *Resurrection*.
Paris, Louvre

its motive power or its substance. The sense that underlies this picture is a reprise, with the altering accent of the classical experience that has intervened, of the baroque intention of the *Assunta:* contrast with the Raphael demonstrates how the pictorial elements in the earlier painting that are comparable have been translated into the language and mentality of a Baroque. We need not elaborate the relation of this altar to the *Assunta* in its density of realized substance, its vitality of action, or its forcing nearness to us; these qualities in the *St. Luke Altar* are, however, all intensified—in scale, in nearness (to which this work adds, beyond the *Assunta,* devices of psychological communication), in the fluency and velocity of discharge of energy from forms, in the pervasive vibration that has been infused into the light, and above all in the magnifying of the means by which Annibale creates effects of optical verisimilitude.

The version of the *Assunta* painted in 1592 (40), in the gallery in Bologna, extrapolates still farther from the Dresden version of the theme in the direction of a Baroque. In it the demonstration of an energy is intensified into the simile of an explosion. Substance is multiplied in a sheerly quantitative sense, and its existence is asserted almost violently in a golden brilliance that blazes from the heaven into which the Virgin ascends, its divine light replacing that of nature. More than in the Dresden *Assunta,* the style of this altar moved into an extreme position, and it demanded pause and reconsideration.

Within the next year, 1593, Annibale had determined what the solution of his probings in baroque experiment and classicizing restraint ought to be: the solution not compromised between the two but dialectic, coercing them into a working fusion. His way of treating a theme essentially similar to the *Assunta,* the *Resurrection of Christ* (Paris, Louvre; 41), manifests the power of mind that evolved this solution. The energy of the action is intense, but it is disciplined into order and perfectly controlled. The forms of

the actors, no less powerfully existential than before, have been given the plastic lucidity of elements of statuary, and their anatomies conform to the idealizing tradition that had come down from the classic masters, referring eventually to Raphael and Michelangelo. The figures are distributed in a scansion of measured intervals, allowing each, within the linkages of the design, its effect of an identity. The design itself is an instantly discernible geometric order, determined by two intersecting circular shapes; diagonal impulses of rhythm and direction make surface ornament and spatial direction for this design but do not diminish its legibility or its integrity.

An assertion in this year of Annibale's new decisiveness of classicizing will is in simpler, and perhaps on this account still more positive, form in his *Madonna with St. John Evangelist and St. Catherine* (Bologna, Gallery; 42). Its structure is almost startlingly reactionary: simple, monumental, and nearly symmetrical, the figures framed and supported by an architecture, and though the figures are grand in scale and of an almost opulent physicality, their actions are contained and gentle and disposed in a compositional *contrapposto*. The whole image conveys the sense of a calculated, measured and evidently idealized beauty, on one hand recalling the character of Raphael's or Titian's most self-consciously classicizing altar paintings, and on the other making a critique, from what is evidently a new point of view, of the painting by Correggio, the *Madonna of St. George* (43), then in Modena (now in Dresden), which served as Annibale's immediate model. Annibale "corrects" the overanimated altar of Correggio in every possible respect precisely in a classicizing sense; and this exercise, in which he reshapes the proto-baroque art of his first great stylistic mentor into a mode of classicism, has the meaning of a manifesto and marks the finally decisive choice between the alternatives that Annibale himself had opened up, of pursuit of the possibilities of a baroque style or the constraint of the newly discovered resources of that

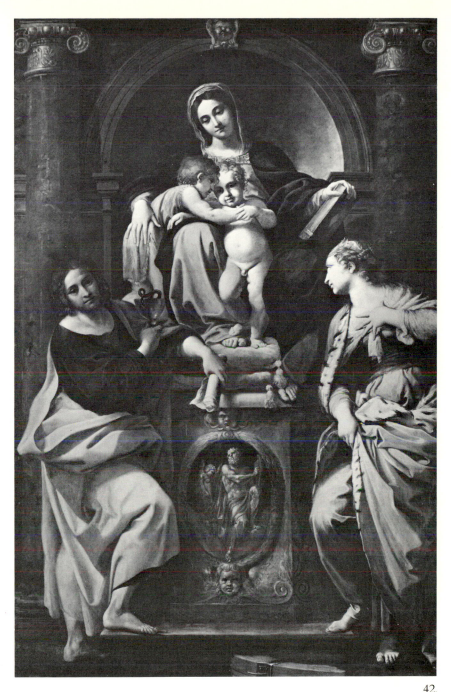

42.
Annibale Carracci,
*Madonna with St. John Evangelist
and St. Catherine*. Bologna, Gallery

[29]

style into the aesthetic—and, it should be observed, at the same time the ethic—systems of classicism. I speak advisedly of constraining the resources of a baroque style into the aesthetic systems of a classicism: what Annibale has defined in this picture, and less obviously in the *Resurrection* altar of the same year, is not a resurrection of the classical style of the High Renaissance, despite the references to it and dependence on it that were essential to Annibale's formation of this present style. This present accomplishment is the founding proposition not only for Annibale's own subsequent achievement but for the widespread and historically significant phenomenon of style which that achievement would serve in turn as threshold for, of a classicism within baroque. In that style, as in this altarpiece, the resurgent ideals of classicism would, in the most literal sense, be *embodied* in the splendid sensuousness of optically defined presence and appearance that were the innovation of Annibale. This new classicism assumes a look and a tonality of meaning (again in a literal sense) *visibly* different from that in Annibale's sixteenth-century models.

The clarity of Annibale's commitment to this new course is evident in his *Madonna above Bologna* (Oxford, Christ Church; 44) of 1593 or 1594, in a design which, though inspired possibly by Annibale's exposure to the *Sistine Madonna* (39) in the original, and to Raphael's *Madonna di Foligno* (45) in engraving, is more doctrinaire in its geometry than either. But the identity of the image as a phenomenon of the new style, and not as a recollection, is even more apparent here than in the *Madonna with the Evangelist and Catherine;* the grand dimension of the Madonna here is not just from a will to achieve a classicizing grandeur, but from a will—baroque in essence—to magnify the splendor of a physical presence, and that presence is conveyed to us in terms that make it vibrant with the excitements of light and texture.

43.
Correggio,
Madonna of St. George.
Dresden, Gallery

44.
Annibale Carracci,
Madonna above Bologna.
Oxford, Christ Church Gallery

45.
Raphael,
Madonna di Foligno.
Vatican Gallery

[31]

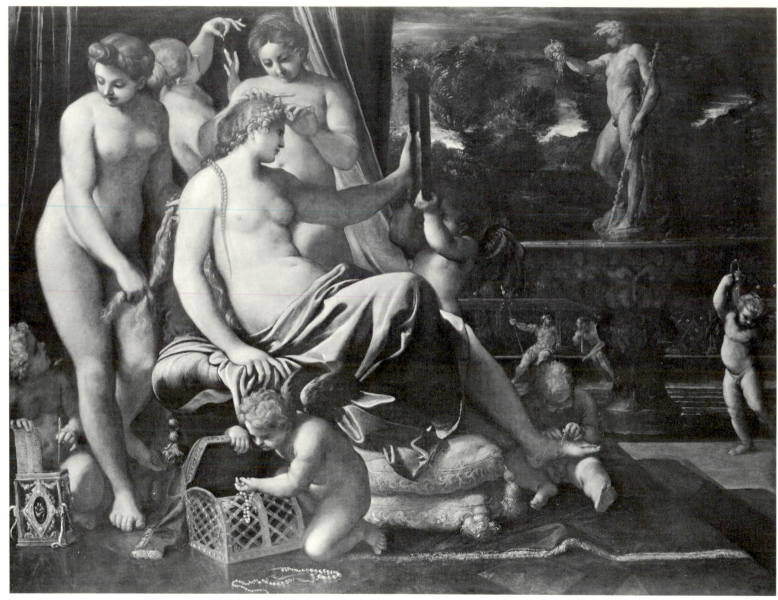

46.
Annibale Carracci, *Toilet of Venus*. Washington, National Gallery, Samuel H. Kress Collection

To a classicism of forms and tonality of expression Annibale added that of ancient subject matter in the *Toilet of Venus* (Washington, National Gallery; 46), of 1594–95. The nudes do not just translate the accustomed models of antique statuary but amplify them, aggrandizing their effect of substance and dimension. However, Annibale makes no corresponding effect in his handling of the sensuous description of these nudes: on the contrary, as if to insist on their ideality as an aspect of both their Olympian nature and the historical distance to which they pertain, he has, as it were, distilled off from the nudes the sensual epidermis of their sensuousness, giving to the bodies a purifying, more nearly even radiance that affirms the descent of their imagery from ancient statues. The intellectually motivated deliberateness of this effect is accentuated by contrast with the opulence of chiaroscuro in the setting and of texture in the accessories. Again, there is a revealing incident of a critique of Correggio's example in this painting. The handmaiden at the left transcribes almost exactly Correggio's poignantly sensual Venus in his *Education of Cupid* (47) but diminishes her sensuality and puts both her nudity and the idea of it at a distance.

A great picture—great in dimension also; it is about five meters long—marks the last accomplishment of Annibale in Bologna before his permanent transfer to Rome in November 1595: the *St. Roch Distributing Alms* (48), done for the confraternity of S. Rocco in Reggio Emilia, and now, like so many others of Annibale's prime Bolognese works, in Dresden. The painting was executed almost altogether in 1594 or 1595, but it had been commissioned, and possibly in some degree begun, as early as 1587–88. Although a conception of design made at that time, when Annibale was in the main concerned with probings toward baroqueness, may account for evidently baroque qualities in the composition, this need not be the case. The armature of design, a brilliantly manipulated play in counterpoint of

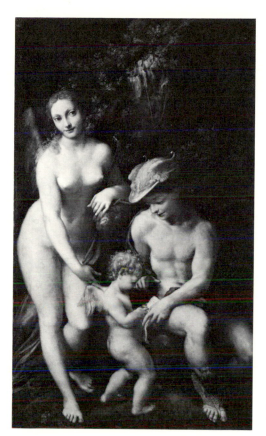

47.
Correggio.
Education of Cupid.
London,
National Gallery

diagonal impulses, locked absolutely into a powerfully charged but precise and finally determining equilibrium, is a wholly appropriate response to the potential for dramatic action in this panoramic *historia;* the principle of modality, which swayed Annibale's stylistic formulations often, was surely operative here. In any case, the *St. Roch* demonstrates at the highest possible level the interaction Annibale had formed between classical principle and baroque device; the baroque impulsion of diagonal design worked not only into counterpoint but within each impulse into disciplined community of direction, in which actions and gestures

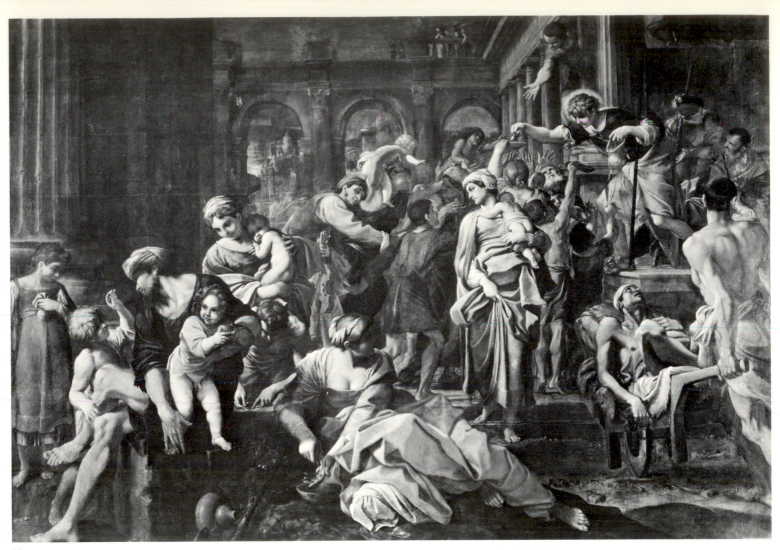

48.
Annibale Carracci, *St. Roch Distributing Alms*. Dresden, Gallery

seem to line up like iron filings responding to a magnet. The charged equilibrium the design finds satisfies, in the end, requirements of classical design no less stringent than for a Raphael: the *Expulsion of Heliodorus* (49), for example, achieves an end effect no different in principle from this. No less important to the temper of the whole, and equally affirmative of its descent from classicism—Raphael's, much more than Veronese's superficial brand of it, as has

for this instance been alleged—is the rhetoric of the picture: in the largeness and emphatic character of the dramatic action; in the demonstrativeness and impressive amplitude of the actors, and the handsome large deliberateness of their postures and their gestures. This is the rhetorical mode not of any North Italian or Venetian model but of Raphael, as it had been invented by him for the Stanze, and climactically developed in his Tapestry

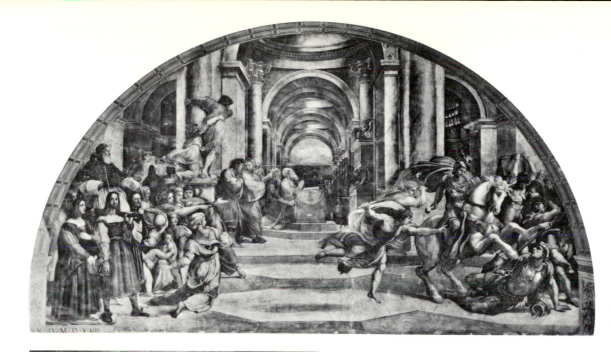

49.
Raphael,
Expulsion of Heliodorus.
Vatican, Stanza d'Eliodoro

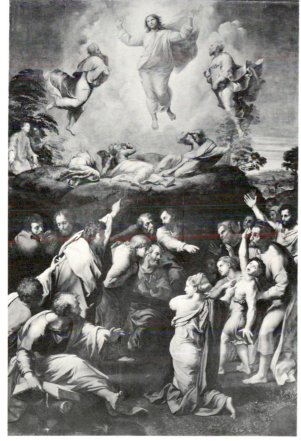

50.
Raphael,
Transfiguration.
Vatican Gallery

Cartoons and in his late *Transfiguration* (50)—Raphael's classical rhetoric, but aggrandized further by Annibale, and extrapolated to the verge of baroque hyperbole.

It is impossible to establish how much of the cast of style in these two works of 1594–95—the reference to antiquity in the *Toilet of Venus,* the analogue to Raphael's mode of rhetoric in the *St. Roch*—may be due to the brief visit Annibale made to Rome late in 1594, but it is explicit that, in any case, the substance of his formulation of a classicism within baroque had been entirely resolved before his definite transfer of residence to Rome, where he was settled by the autumn of 1595. The classicism his Roman paintings manifest perfects and clarifies what he had laid down in Bologna, and it acquires a specifically Roman accent, compounded from the examples of ancient art that Annibale could see there in unparalleled abundance and from the High Renaissance interpretations of antiquity.

Annibale had come to Rome to enter into the service of the Farnese, and from 1595 to 1597 he performed his first work for them in the decoration in their great Roman palace of a room called the Camerino, of which the theme was

draperies no less than in the flesh—disciplining baroque vibrance toward modulated continuity. This process does not make a diminution of the figures' existential power; it is a clarifying and a distillation of it, appropriate to a classical mentality. Further, what the figures lose in optical effects of sensuous immediacy they replace with their effects of clarity and certainty of presence. Their illusion has been lessened but their verisimilitude has not, and by the sense of a distillation that they give they are more appropriately seen as dwellers in a distanced, Olympian sphere.

From the Camerino Annibale transferred his attention to the much larger project of decoration of the vault of the great salon in the palace (55), where he worked, assisted on occasion by his brother Agostino, from late 1597 to the end of 1599. The reason for the decoration was apparently an impending marriage, to be celebrated in 1600, between the young Ranuccio Farnese and Margherita Aldobrandini, daughter of an allied great Roman house, that of the then reigning pope, Clement VIII. The theme of the decoration, the *Loves of the Gods,* was taken with the meaning of an epithalamion, an ode in celebration of the marriage. The theme accounted for the subjects Annibale was to illustrate, but not for the scheme in which he chose to represent them. That proceeded from another preexistent circumstance: that the salon was a gallery in which the antique sculpture of the Farnese collection was displayed. This suggested to Annibale the brilliant thought of treating his scenes on the vault as if they were pictures hanging in a gallery (56): as an assemblage of illusionistic semblances of framed paintings (*quadri riportati,* as the current language called them) and sculptural reliefs, hung upon or inserted into a framework of fictitious architecture—an architecture made with paint apparently to extend and crown the gallery's real walls.

The painted architecture extends the luxury of decoration of those real walls. The fictive superstructure encloses

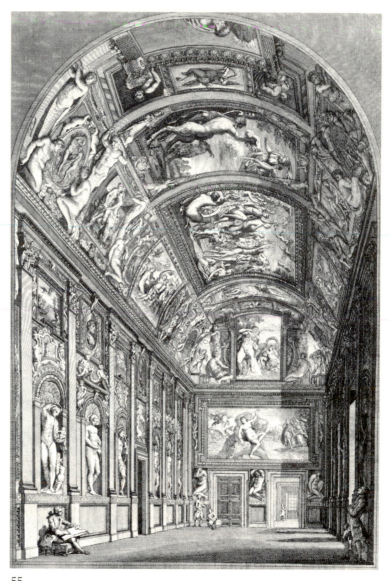

55.
After Giovanni Volpato,
Farnese Gallery

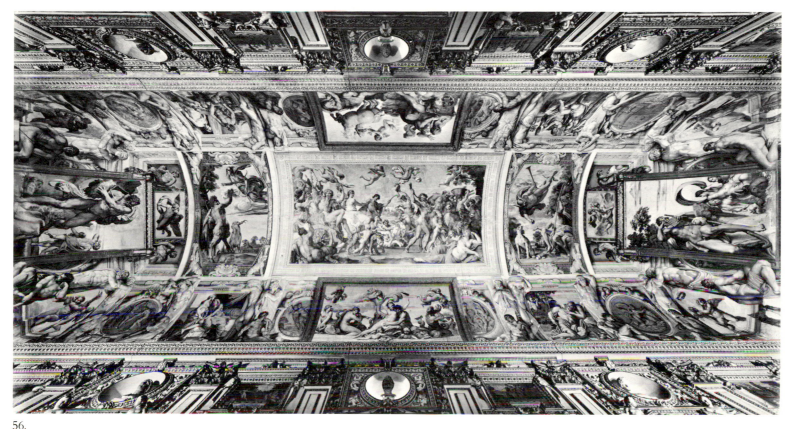

56.
Annibale Carracci, *Farnese Gallery*. Rome, Palazzo Farnese

an addition to the space a story high above the actual cornice; at the corners it is open to an apparent outside sky. The long sides of the superstructure are divided into alternating bays of simulated relief sculpture and paintings inserted into fictitious picture moldings; in the center is a *quadro riportato* in the most exact sense, heavily framed as if it were a canvas. Terms or Atlantids, made in monochrome paint to convey the illusion that they are stucco sculptures, handsomely and heavily divide the pictorial and sculptural episodes. On each short wall, a great vertical picture, framed with paint as if it were an easel work, leans forward in space and rises above into the superstructure to its very limit. Across the opening to a painted sky we here perceive, two smaller "pictures" hang as a bridge to two large scenes, these now pretending to be tapestries, which, stretched across the upper space, would shade us from the "sky." These in turn adjoin a large central painting that is contained in what seems to be an architectural molding

58.
Michelangelo and others,
Sistine Chapel.
Vatican

57.
Raphael, *Story of Psyche*.
Rome, Villa Farnesina, Loggia di Psyche

rather than a normal picture frame, as if this central scene were a fixed element in the decorative scheme. Around the bottom of the painted superstructure, below the Terms and posed as if they were sitting on the real cornice of the gallery, are nudes in color, whose derivation from Michel-

angelo's *Ignudi* is instantly obvious and was meant by Annibale to be.

The complexity of the system of fictitious architecture Annibale has projected in paint upon the vault precludes our trying to describe and analyze it in detail, but we

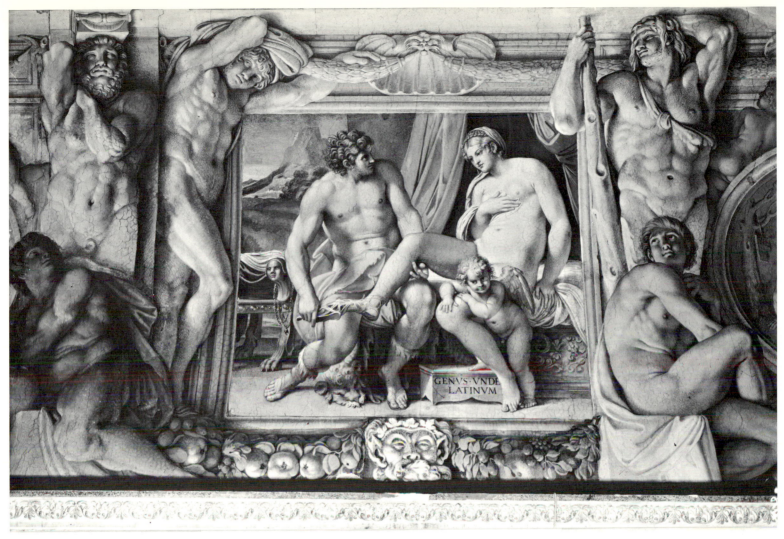

59.
Annibale Carracci, *Farnese Gallery*, detail, *Venus and Anchises*

should note how, with the stimulation of close contact with the Roman world, Annibale has made in this scheme a transmutation of the precedents of the High Renaissance that is more inspired and original than any previous painter had achieved. Raphael's *Story of Psyche* in the Villa Farnesina (57) was of necessity referred to, and from it came the idea of covering the center of the vault with images in the mode of *quadri riportati*, avoiding thus the logic, destructive to a classical unity of decoration, of foreshortening illusion. From Michelangelo (58) came the basis for the idea of a framework of interlocking elements of architecture projected in paint onto the ceiling, in which some figurative elements display at least in part the character of illusion, while others contradict it. In one respect Annibale's

[41]

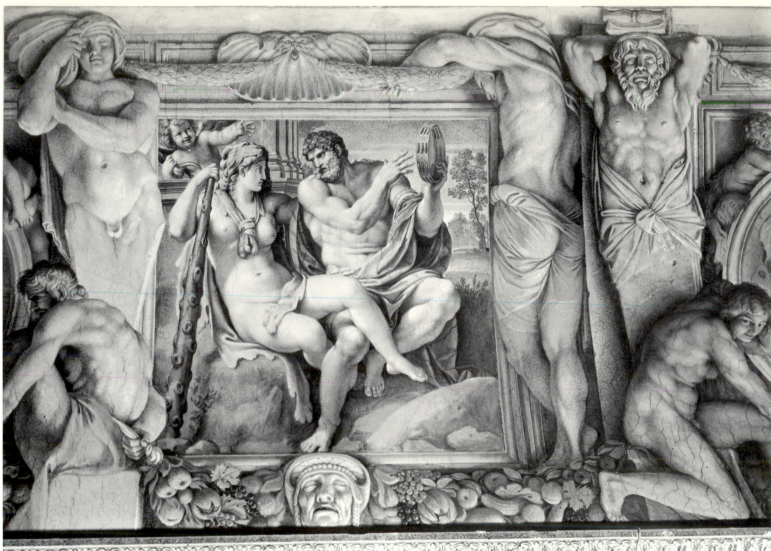

60.
Annibale Carracci, *Farnese Gallery*, detail, *Hercules and Iole*

scheme conveys a sense more like Raphael's than Michelangelo's: the vault of the Farnesina, like that of the Farnese, seems to contain the spectator spatially and psychologically as if in the shelter of an umbrella; the vault of the Sistine does not contain but only surmounts him. More than either, however, Annibale creates the effect in both the pseudo-architecture and the figurative elements of his vault (59, 60) that they are palpable presences. The forms of architecture are transformed fluently and almost pervasively into the human forms of fictive stucco sculpture, which despite their monochrome inspire in the spectator's eye and imagination no less a conviction of their presence

[42]

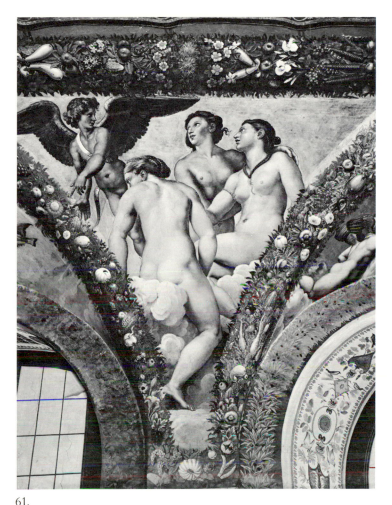

61.
Raphael, *Story of Psyche,* detail, *Three Graces.*
Rome, Villa Farnesina

than the actors in the paintings they enframe. Before the stucco sculptures, on the cornice, in a space of illusion that appears as if halfway into our own, and in our light as well, the Ignudi are live, flexible, and touchable existences.

The life Annibale has spread out on the Farnese ceiling seems, by comparison with its early sixteenth-century antecedents, to pullulate and be intensely present, yet the mode of ideality to which its forms have been reshaped is in most ways not so different. Annibale's manner of magnifying his anatomies and endowing them with clarity of form and regularity of proportion is close to Raphael's (61) and still more doctrinaire than his; in some respects Annibale's actors seem more distant. Yet there emerges from Annibale's figures what we have perceived already in the *Choice of Hercules:* a distilled sensuality, compounded from the nudity that has been illustrated and a quality of surface on it that is as if caressed by light. This emanation to the spectator's psyche, combining with the illustration and aggrandizement of presence, makes a power of felt existence that is not in Annibale's models but is of his own time and, we must not forget, of his invention. A comparison with Michelangelo's models (62) eloquently demonstrates the difference of Annibale's effect. The comparison provokes an observation on the nature of Annibale's ideality, however; formally no less than Michelangelo's, it is philosophically—or, perhaps more exactly, morally—in a less exalted sphere.

The analogue, in regularity of grand proportion and lucidity of surface, to the actual sculpture that populated the gallery below is reserved in that degree for the deities whose *amours* Annibale depicts: there is a matching of form to an idea of content, and it is adjustable on just this basis. The Ignudi who sit illusionistically as if before the narrative scenes and on the actual cornice (63) are not Olympians, separate from us in a discrete pictorial space, but creatures intermediate between Olympia and us. Aggrandized in anatomy, in imitation of the nudes of Michelangelo they so purposely recall (53), they are of a more flexible, less geometry-suggesting form than the Olympians; their physiognomies, too, are less beautifully recast. Further, their bodies are revealed to us in a light distinct from

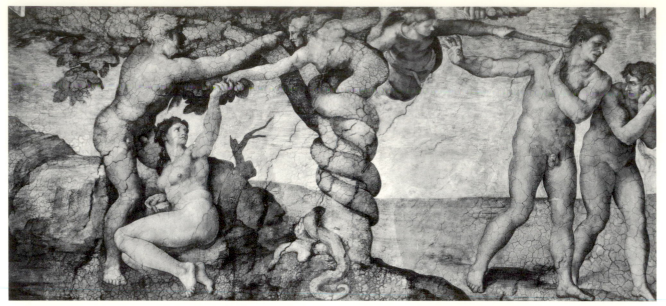

62.
Michelangelo,
Sistine Ceiling, detail,
Temptation and Expulsion.
Vatican, Sistine Chapel

63.
Annibale Carracci,
Farnese Gallery, detail,
Ignudi and Atlantids

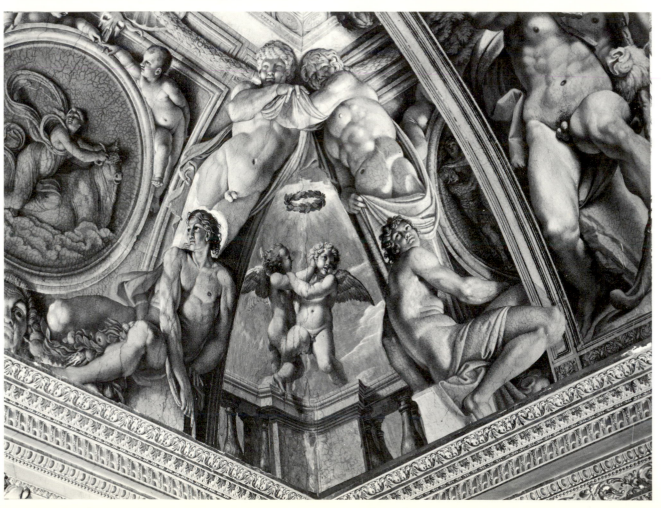

64.
Annibale Carracci,
Silenus Picking Grapes.
London, National Gallery

the light illumining our view beyond the Ignudi into Annibale's Olympus; as the Ignudi on the cornice share our space they share our light as well, and it works upon their bodies with a texturing complexity that affirms the truth and nearness of their presence. Their anatomies are also more detailed than those of the gods, and their expressions of countenance are manifold and psychologically precise. The sphere of ideality to which Annibale has raised them is specified by his artistic means to be at most halfway between us and the gods, exactly as their situation in the scene requires. The contrast of Annibale's Ignudi with the images of Michelangelo in which they take their origin affirms that, whatever their relation to the artistic past, the essence of Annibale's conception is of his own invention and only of his time. But what is also on the Farnese ceiling that is particular to Annibale, and indicative for his time, is an affirmation of a pleasure in existence; more than plea-sure, it seems an expansive and commanding joy, which comes not from the narration but from the radiance that emerges from Annibale's recreation of a physical world.

There is a byproduct in small scale of the manner of the Farnese decoration, done close to the time when the ceiling was approaching its completion in 1599, in two fragments with Bacchic subjects (now in London, National Gallery; 64, 65) from the decoration of a cembalo, to which Annibale has transferred the modality in which he painted the Farnese nudes. The Bacchic themes (*Silenus Picking Grapes* and *Bacchus with Silenus*) are traditionally vehicles of humor, meant—all the more so in their association with the musical instrument they once adorned—to inspire amusement and an intimate delight. The Farnese decoration, on grand scale, had of necessity to work in large effects and with constant implication of a rhetoric. The small paintings display the other end of Annibale's aesthetic

[45]

65.
Annibale Carracci,
Bacchus with Silenus.
London, National Gallery

range: a most refined and complex lighting, reverberating against the background (even the arbitrary but wholly atmospheric-seeming one of gold leaf) in which the figures seem most live and tangible resurrections of a pleasure-imbued pagan world. The intimacy and fineness of visual and physical sensation that Annibale sets forth here are the counterpart of the sensibility he has employed in psychological description: the personalities of the actors are no less vibrantly made alive for us than are their persons.

Sensibility in this extraordinary degree of fineness articulates great power of emotion in a religious painting that comes from this time or very shortly later, a *Pietà* (66), now in Naples, of 1599–1600. Grand forms deduced from what is again an inescapable example in Michelangelo (67) are remade into a more evidently classical and heroic beauty, and adjusted in their composition so as to make, with baroque disposition, a counterpoint of rhythmic movements as well as weights. The alteration of the Michelangelesque design remembers the most nearly baroque precedent in Correggio, the *Pietà* now in the Parma gallery

(28), and Annibale remembers from it also what Correggio had demonstrated to him of emotional sensibility. As lyric and pathetic as in Correggio, Annibale's emotional response is effectively mimetic, but it is even more essentially aesthetic, inspiring the warping, tormented beauty of the movement of each line and the palpitation of the chiaroscuro light. But Annibale, now fixed in his mold of classicism, has—as has now become his habit—corrected Correggio even as he has recalled him.

The *Quo Vadis, Domine* of 1602–3 (London, National Gallery; 68) speaks a much more doctrinaire version of the classical language Annibale had perfected in these Roman years. Although it is a small picture (barely eighty centimeters high), its lucidity of form and expressiveness of content enlarge it greatly in the viewer's mind. The figure of the Christ comes toward us as a simple and impactful form, blunt and emphatic in his action. Peter, set in profile counter to the frontal Christ, reacts to the divine apparition with similar emphasis and simplicity. A strong but only modestly inflected light reinforces the lucidity of form and

66.
Annibale Carracci, *Pietà*.
Naples, Capodimonte Museum

67.
Michelangelo, *Pietà*.
Vatican, St. Peter's

68.
Annibale Carracci,
Quo Vadis, Domine.
London, National Gallery

at once clarifies and strengthens color. The discipline Annibale has imposed on his artistic means is in every respect more stringent in the *Quo Vadis* than we have ever seen it before; but it must be observed that what we may think of as an increased abstractness of design and of some elements of form does not diminish the power of existence in the picture. Indeed, the process that resembles abstraction most certainly intended its effects to be the opposite: a

higher immediacy and urgency in presence and in communication of idea. It is nonetheless perceptible that there is, from this time on, a change in the tenor and intention of Annibale's classicism: a new austerity of mind and stringency of means inform his style. From an aesthetic principle, classicism has now been elevated to a dogma, moral as well as aesthetic.

One last work we shall consider exemplifies in its best

69.
Annibale Carracci, *Pietà*.
London, National Gallery

aspect what happened in Annibale's art in consequence: a *Pietà* (also London, National Gallery; 69), not later than 1605 in date, makes an order of extraordinary rigor. The figures in the painting are arranged almost as if they might be building blocks, in a sequence established by a most arbitrary and barely flexible geometry. Yet even as a geometry the design moves, impelled not only by the human actions held within it but by its own internal logic: a stepped sequence rises from the dead Christ to the left, traverses sharply to the right, and then descends to discharge upon the Christ again. The scheme carries the viewer through the stages of a narrative in which each step is a prodigious declaration of emotion: concentrated, stylized, and explicit, and of most penetrating power. The extreme constraints that Annibale has intellectually imposed upon the image do not limit its dimension of emotion; on the contrary, they intensify and magnify it, in the way that is characteristic of the aspirations of a highest classical style—which Annibale has, at this moment in his career, achieved. But this classicism remains now as ever a classicism within ba-roque: presence is as actual as it is poignant, and it is conveyed in a vehicle of light that intensifies the life of feeling as well as of form and exalts the radiance of color.

An almost wholly incapacitating mental illness, which took the form of an acute and pathological variety of melancholia, began to manifest itself in Annibale about 1605. It seems soon to have made it impossible for him to paint, though he seems to have been able to continue, in a most limited way, to direct his studio and to give some ideas for design. Annibale died in 1609, not yet fifty, leaving to the pupils he had gathered to himself in Rome a legacy that would become in their hands the classical mode within the style of the Baroque, but leaving also to the wider world of art in Italy the example of his own early essays, prior to his classical decision, in the making of the bases of the Baroque style as such. He was the giant of creation of his time, and his accomplishment would bear fruit long beyond that of the only artist in his world who could rival him in artistic merit and in dimension of humanity—Michelangelo da Caravaggio.

II

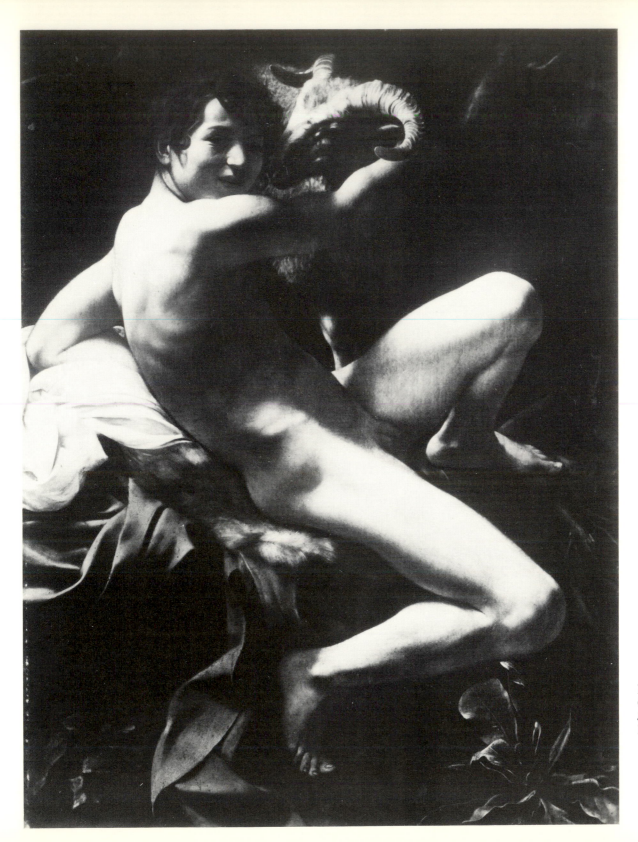

PLATE II.
Caravaggio,
St. John the Baptist with a Ram.
Rome, Capitoline Gallery

CARAVAGGIO

No OTHER IMAGE OF THIS moment in Italian painting makes so powerful an assault upon our sensibilities as Caravaggio's *St. John the Baptist with a Ram* (in the Capitoline Gallery in Rome; plate II). A work of his early maturity, about 1602, it stands in an extreme degree for what, in the context of the recent past as well as Caravaggio's contemporary world, was radical and inventive in his art. Recognizing that it is an extreme statement, we may use it on just that account to make a more pointed demonstration.

The past reigning style of Mannerism offers its characteristic conception of the theme of the young Baptist in a painting by Agnolo Bronzino (Rome, Borghese Gallery; 70) from the middle years of the preceding century. This asserts a presence which in some ways seems as forceful as Caravaggio's, and which depends like Caravaggio's on the affirmation of effects of visual truth. Bronzino's nude has a sharply defined verity of description in the parts of its anatomy; however, opposite to Caravaggio's nude, Bronzino's whole figure gives the effect not of actuality but of artifice. The very model Bronzino has chosen, to begin with, affirms his remove from ordinary reality: he is a high-bred youth, of fine and classicizing feature and, for all his evident power of body, no less fine and classicizing anatomical form. Bronzino has defined that form by graphic means conjoined with the means of plastic modeling, as if he meant to recreate for us less a body of palpable flesh than the image of a sculpture. The semblance of statuary that has been given to the figure has made it seem asensuous; nevertheless, it conveys a quality of distilled and eccentrically displaced sensuality. As we regard Bronzino's image we experience complex and ambivalent sensations, some of them internally contradictory, and our experience of it is diffuse and faceted. But it is Bronzino's initial approach to the representation of the form that results in such diffusion: the extreme acuity of attention focused on the description

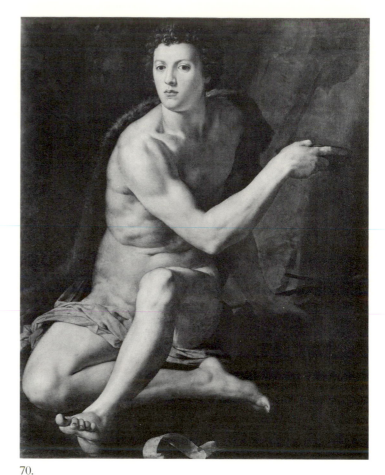

70.
Agnolo Bronzino, *St. John the Baptist.*
Rome, Borghese Gallery

of each part is of necessity divisive—faceting and analytic. We are each moment made more aware of the operation in Bronzino's image of a complicated apparatus of intellect: the processes of high and abstracting intelligence are here communicated by the most disciplined formal working of the hand. The presence Bronzino's picture so commandingly asserts does not result from the reproduction that

may be in it of nature; the reality it conveys is that of its powerful reality of art.

In the art of Caravaggio's great near-contemporary, Annibale Carracci, intellection and idealization remain prime operative powers. Annibale's *Ignudi* of the Farnese ceiling

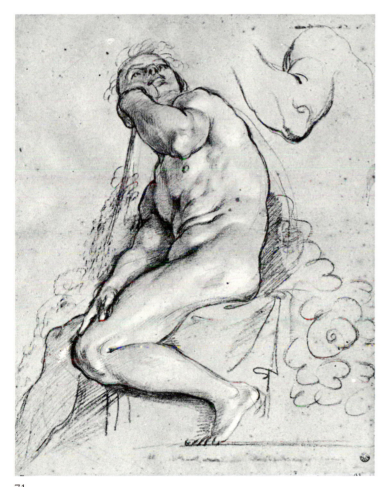

71.
Annibale Carracci, *Model Study for an Ignudo of the Farnese Gallery*. Paris, Louvre

(63) make overt reference to the precedent of Michelangelo (53), reinforcing the role in them of the ideal; at the same time, Annibale's nudes were, far more than Michelangelo's, (literally) embodied, the ideal in them incorporated into and compromised with forms that have been optically and sensuously perceived. Even when, as in a study for one of the *Ignudi* (71), Annibale immediately confronts the model, his notation of what he looks at, for all its texture and aliveness, is from the beginning conditioned by a measure of intellectual arranging and idealization. What we may call "realism"—in the most conventional and pragmatic sense in which the word is used by art historians—is a basis and a starting point in Annibale's creative process, but in his mature art it is never its main end. It was only in his first traceable beginnings that Annibale, as we have seen in his *Dead Christ* of ca. 1582 (in Stuttgart; 11), had thought the reality of the unidealized model a sufficient purpose; he quickly came to reincorporate the traditional requirements of an ideal style.

We have a context now for Caravaggio's *St. John,* and the first consideration the image impresses on us in this context is that the figure has been seen by Caravaggio apparently without the intervention of any of the traditional idealities. Caravaggio seems indeed to have selected his model in defiance of the requirements of idealism, and he has willed to present him physically and psychologically in a way that makes him in the most extreme degree actual—immediate, literally without any intermediary between the model-image and ourselves. Caravaggio's apprehension of the model's presence seems unimpeded in the least degree by any intervention of the intellect or by those conventions of aesthetic or of ethic that the intellect invents. The image Caravaggio presents to us is essentially the sensuous perception of a physical fact; the psychological record accompanying it is only such as is required to imply the meaning that this sensuous presence may have for the viewer.

This presence is of an aggressively naked youthful male, and in the context of our biographical information about Caravaggio and our understanding of the pictures he painted prior to this one, we recognize that this image is homosexual in its essential content. One might juggle with platonic notions of the picture's sense or try to palliate the subject by lending it an Old Testament or even a mythological rather than a Christian label, but it is most likely that none of these was meant. In any case, the nominal subject matter is of no more than tangential import, since the real meaning and the nominal theme diverge from one another: the Baptist with the sacrificial ram, or whatever other subject may be proposed instead for it, is merely a figleaf imposed upon the real meaning of this picture. The real theme is not a narrative, an allegory, or an emblem; it is a presence, and the meaning of the presence is the sheer sensory experience of it and the emotions this experience is meant to generate.

The artist's seeing of the model and the action of his hand that records the seeing are absolutely immediate to his brush. His perception has been conveyed to the canvas without the intervention, or the consequent deliberation, of any studies in drawing—in this he is unlike Annibale Carracci most conspicuously; and his process of recording is as intense as it is direct. There is no precedent for this degree either of intensity or directness in any prior art. The seeing impelled by this intensity grasps its object and experiences it as if at highest speed, giving the effect of an instantaneous apprehension of the whole. The act of apprehension is including and integral, a unity as well as an instantaneity; and in this apprehension optical and tactile experience—or, more precisely, the sense in the mind of tactile experience—have been fused, reinforcing one another, absolutely interpenetrating, to make an effect which far exceeds that of either kind of experience by itself.

The way in which Caravaggio relates to this seen image —but not only to this particular kind of image, it should be understood—is as if to a love-object. He translates into his act of art the lover's experience of seeing and touch, which he has galvanized at that very instant where, in a living situation, seeing would be turned into touching. Visual sensation is intensely charged, containing a high tension and generating more. The artist is by nature a voyeur, and here Caravaggio has created a voyeuristic situation into which the spectator, as he takes the painter's place in front of the completed canvas, necessarily must fall. The meaning of the picture thus depends not only on the presence Caravaggio has evoked in it, but on the situation he has now made. There is no very meaningful action or emotion that occurs within the painting; what is meaningful comes instead from the relationship established initially between the artist and the model and then, as we are the surrogate for the painter when we look at the picture, between the model-image and ourselves.

This is anything but a still-life mode of response to experience, despite Caravaggio's prior episodes of interest in still life. The quality of attention and the efficacy of description may indeed be those of a painter of still life, but the situation that has been created between the spectator and the picture is very different from what he would confront in a still life. This situation posits a relationship between persons, and requires what we may describe as a transaction of experience between them. Each confrontation with the image recharges it, as it were, with the life of this transaction.

Yet, even as it inescapably demands relationship, the image retains the character of a thing apart from us: a presence and a personality that Caravaggio has objectified. The objectivity is not just in the painter's truth of physical description but also in the psychological characterization, and beyond that it arises from Caravaggio's management of the aesthetic factors of which the painting is composed.

The objectifying of the psychological component of the image is difficult to characterize from the single picture in itself; it is better demonstrated by a comparative process which shows how it evolved from Caravaggio's preceding paintings.

The *Fruttaiolo* (the *Young Fruit Vendor,* in the Borghese Gallery in Rome; 72), is almost a decade earlier than the

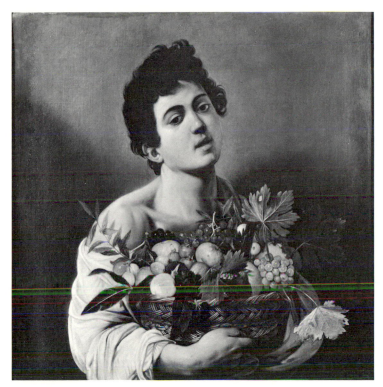

72.
Caravaggio, *Fruttaiolo*
(*Young Fruit Vendor*).
Rome, Borghese Gallery

The latter are the easier to explain: the planar setting of the body; the self-containing, regulating arrangement of the limbs into a *contrapposto;* the logic of an evident geometry that relates the image to the picture field and seems to lock it there, holding it thus separate from us. Despite his pretense of a contrary premise, the intellectual devices of past tradition have in fact not been rejected by Caravaggio— nor, obviously, could they be; but they have been masterfully occluded by the clamor he has made in front of them with his assertion of vulgarian reality.

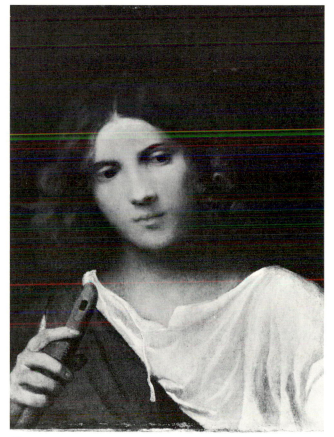

73.
Attributed to Giorgione, *Shepherd with Flute.*
Hampton Court, Royal Collection. Reproduced by courtesy of H. M. the Queen (copyright reserved)

74.
Caravaggio, *Musica* (*The Music Party*).
New York, Metropolitan Museum

Capitoline Baptist; it was painted shortly after Caravaggio's arrival in the capital, about 1593. In this early picture the real meaning, beneath the apparent subject matter of genre-cum-still-life, is the same as that in the *Baptist*. The

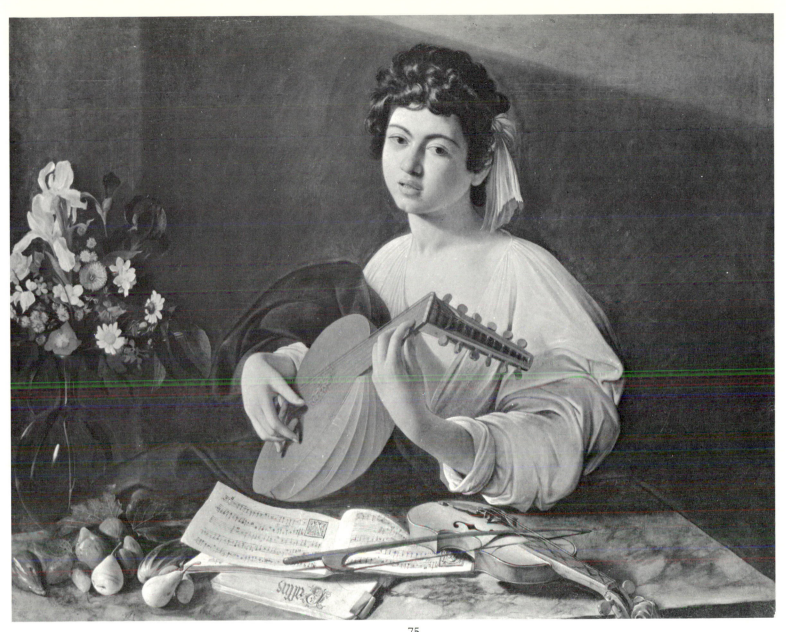

75.
Caravaggio, *Lutenist*.
Leningrad, Hermitage Museum

psychological characterization of the model conveys a ro-
manticizing tenderness, which despite the element of genre
suggests the working upon Caravaggio of a mode of feel-
ing he would have seen in Giorgione (73); it is virtually
certain that the young painter had had an experience of

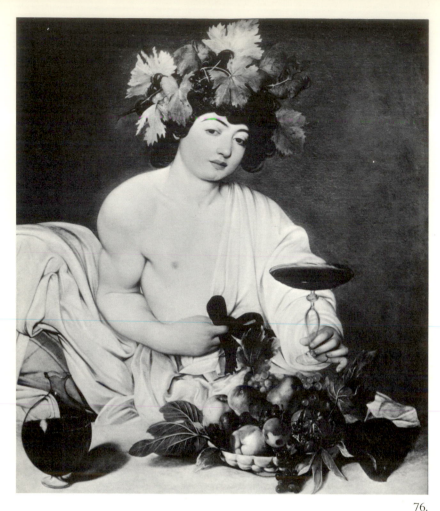

tains should be seen as its inspiring motive, not as an adulterant. Again a year or two later in time, the *Lutenist* of the Hermitage (75), of about 1595–96, begins to demonstrate Caravaggio's process of objectifying his relationship to his models: as the power develops in him of objectifying the description of the form, simultaneously and in parallel with that development and as a function of it his power of objectifying feeling develops also. As the figure acquires an appearance more certainly separate from us, so does its psychological identity become discrete. By the time of the Uffizi *Bacchus* of 1597–98 (76), the articulation of a psychological distinction of the model from the spectator is close in degree to what the *Baptist* shows.

76.
Caravaggio, *Bacchus*.
Florence, Uffizi Gallery

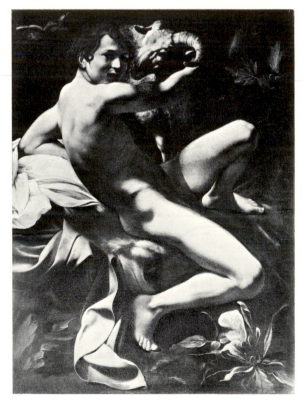

77.
Caravaggio, *St. John the Baptist with a Ram* (replica).
Rome, Doria Gallery

Venice. The *Musica* of the Metropolitan Museum in New York (74), of a year or so later, ca. 1594, illustrates still more compellingly the sense of a sympathy between the artist and his models. The models demonstrate the projection upon them of the artist's feelings: almost sentimental, and lyrical not only in the tonality of feeling but in the emotive affect he has imparted to the represented forms. The feeling is as genuine and as authentically poetic as it is tender, and the particular sexual implication it con-

The sole instance that we know of an authentic replication by Caravaggio of one of his own works is a second version of the *Baptist* picture (77), in the Doria Gallery in Rome. It demonstrates no less than the first, Capitoline, version how, by the time of his early maturity of style, Caravaggio came to observe and record the psyche of his models with an effect of separate and living truth within the real world, no longer trammeled in the psyche and emotions of the artist. He has interposed a small but very sensible psychological distance between us and the model-image, which does not lessen its immediacy or decrease its power of communication, but which makes our experience of it like that of a true reality, uncompromised by the artificial subjectivity that art supplies. This psychological distance between viewer and image is no void; it is, rather, like a spark gap; prodigiously charged, it is the bridge for a relationship which is, in both the human and aesthetic dimensions, phenomenally live.

Caravaggio's process of maturing was, as we have already noticed, not only an internal one. It was accelerated by the sense that Caravaggio must have felt of difference from his immediate artistic context and, as well, from the art-historical past: the sense of difference, which we too must feel strongly, emerges more and more with each new personal expression, and as it emerges it is inevitably self-reinforcing. By the century's turn Caravaggio's new way had acquired the character of an aggression against his context of contemporary art and even more against the sources in the Cinquecento past of the present's persistent habit of idealism, conspicuous, for a prime example, in the art of Annibale Carracci. There are deliberate episodes, of which the *Baptist* is among the most explicit, of aggression toward the great deities of sixteenth-century painting, Michelangelo in particular. A deliberate translation into realist prose of overt classic sources on the sacred *Sistine Ceiling* (78), the *Baptist* is not just anti-ideal; it is a derisive irony, and in a sense a blasphemy, which intends an effect of sacrilege and shock—to which its contemporary audience would have been more susceptible than we. The *Amor* (in Berlin-Dahlem; 79) of 1601 or 1602 is a still more drastic inversion in this same vein (80). The measure of Caravaggio's aggression against Michelangelo is in proportion to the latter's towering ideality, but there may be a less theoretical basis for it—a reaction to Michelangelo's veiling and sublimation of a sexual disposition that Caravaggio in his art had made overt. The relation to Michelangelo's example is, however, two-faced: Caravaggio is awed by what provokes him to attack, and like all acts of blasphemy these of Caravaggio are inescapably ambivalent.

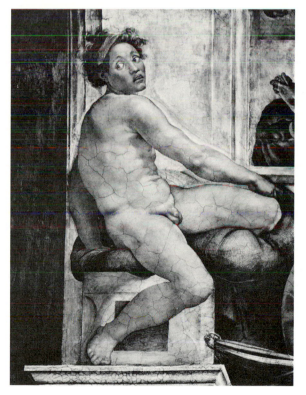

78.
Michelangelo,
Sistine Ceiling,
detail, *Ignudo*.
Vatican,
Sistine Chapel

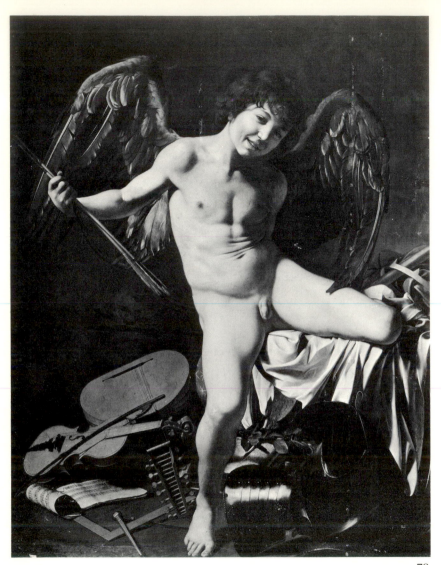

79.
Caravaggio, *Amor*.
Berlin-Dahlem, Gallery.

Pictures like the *Baptist* and the *Amor* are at least in part polemic, and they may be taken as nonverbal manifestos of Caravaggio's anti-ideal posture. As he matures, Caravaggio insists that the mission of the painter is not only to describe realistically; he insists further that what he chooses to describe be real in the sense of being ordinary or, even more, common, *popolano*—of the people not just in appearance but in expression and behavior. The painter's representation must be unstyled, without rhetoric and without *maniera*. In Caravaggio's whole mature work there is no mythology or ancient history, and except for the *Amor* there is no classical literary theme. Yet despite the *popolano* world that the art of the mature Caravaggio describes, there is no genre either, though genre in Seicento art would derive from what he paints. His religious themes are

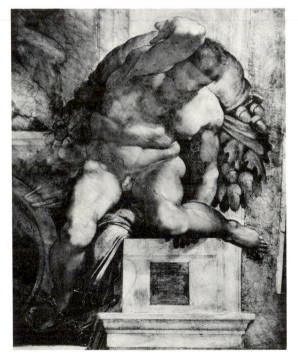

80.
Michelangelo,
Sistine Ceiling,
detail, *Ignudo*.
Vatican,
Sistine Chapel

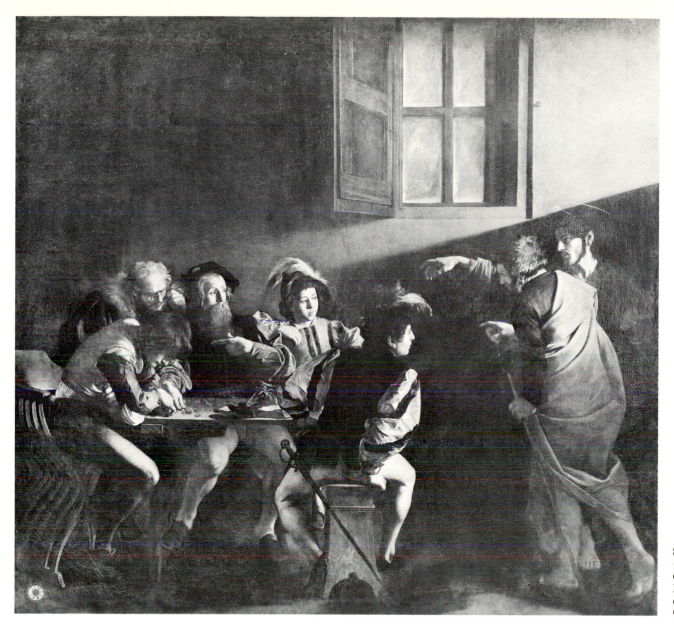

81.
Caravaggio,
Calling of Matthew.
Rome, S. Luigi
dei Francesi,
Contarelli Chapel

acted out by persons from the realm of genre in places that could frame genre scenes, and the technique which describes them is that which genre painters come to use. However, this implies no submission of religious art to genre; very differently, this is a new kind of religious art, which makes its persons actual and its subject matter utterly contemporary, most poignantly of *now*. This begins with Caravaggio's first public and large-scale commission, the *Calling of Matthew* in the Contarelli Chapel of S. Luigi dei Francesi of 1599 (81), and becomes still more evident in

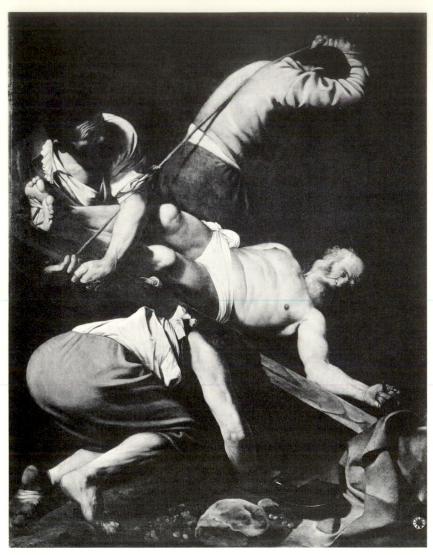

82.
Caravaggio, *Crucifixion of St. Peter*.
Rome, S. M. del Popolo, Cerasi Chapel

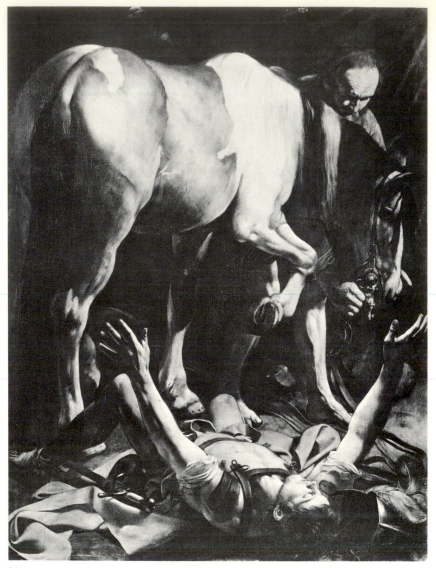

83.
Caravaggio, *Conversion of St. Paul*.
Rome, S. M. del Popolo, Cerasi Chapel

the paintings of 1600–1601 in the Cerasi Chapel of S. M. del Popolo in Rome (82, 83); it is explicit in a painting of a briefly later moment, most likely 1601–2, the *Supper at Emmaus* in the National Gallery in London (84).

The logic of the case suggests that painting made from such a realist premise should be a kind of anti-art, in that it seems to reject all the apparatus of art that does not serve the immediate purpose of representation and communication; and from what we have observed of Caravaggio's relation to the High Renaissance, it should be anti-classical as well. But in evident fact the discipline of form and struc-

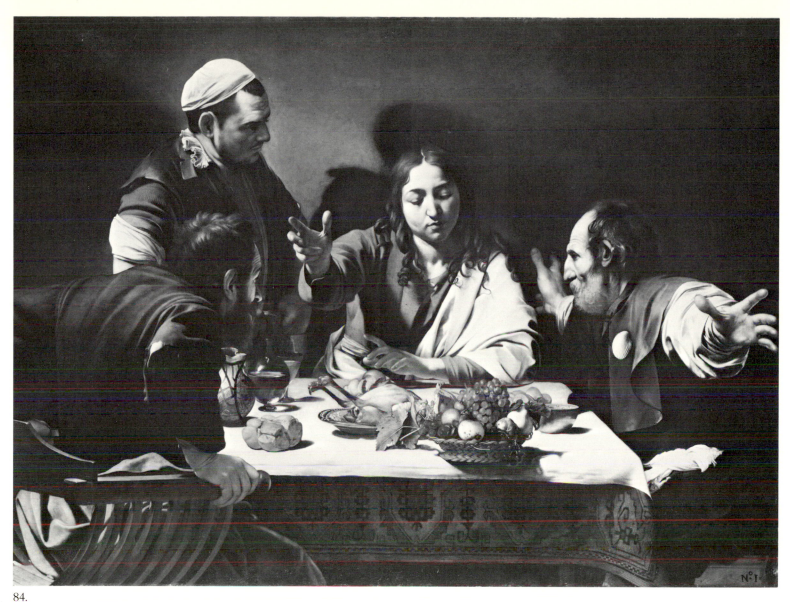

84.
Caravaggio, *Supper at Emmaus*. London, National Gallery

ture that Caravaggio exhibits in these works is quintessentially artistic, and it is also classical in kind. There is a sense in every part—let us take the *Emmaus* as example (85)—of the action on it of a strongly shaping, summary geometry; in the relation of each part to its including form there is a sense of lucid sequentiality, and in the whole image a clarity, coherence, and stability of relationship that makes an order of an explicitly classical kind. This formal order illustrates a consonant order of emotion, lucid, stilled, and strong, arresting drama in a powerfully charged instant in a

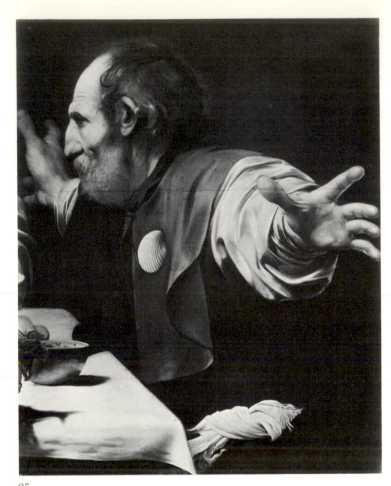

85.
Caravaggio, *Supper at Emmaus,* detail.
London, National Gallery

86.
Caravaggio, *Entombment.* Vatican Gallery

way that recalls a central dogma of the early Cinquecento's highest classical style. We are accustomed in conventional art history to think of Caravaggio as the great protagonist of Seicento realism, while Annibale Carracci stands as the defender of the principles of classicism; but should we compare a mature and typical work by Caravaggio, his *Entombment* in the Vatican (86), of 1602, with Annibale's *Pietà* in London (69), of about 1605, we must observe that in essential ways Caravaggio's work is not less classical than Carracci's. The Caravaggio demonstrates no less coherence and economy of form, and an equally stringent discipline of feeling, and in the Caravaggio no less than in the Carracci there is a studied rhetoric that descends from the classical tradition.

87.
Annibale Carracci, *Assumption of the Virgin.*
Rome, S. M. del Popolo, Cerasi Chapel

In the course of the painting of the Cerasi Chapel a curious instance occurred of what seems certainly to be a cross-influence between Caravaggio and Annibale. The commission for this decoration was in fact a shared one; while the laterals with St. Peter and St. Paul were assigned to Caravaggio, the altarpiece, an *Assunta* (87), was given to Annibale, in exactly the same time span, 1600–1601. In this close contact Annibale recovered from Caravaggio's example some of the conspicuous interest of his own beginning years in realism, and in the *Assunta* recalled that it was he, not Caravaggio, who had first conceived the idea of a *popolano* typology, which he here describes not in his native optically oriented vein but with a hard-shelled surface of Caravaggesque kind. Caravaggio responded oppositely to Annibale, or at least to some of the ideals that Annibale shared with the more traditional painters of the Roman school. Caravaggio did two versions of the laterals for the Cerasi Chapel; for reasons we do not know, the first pair was withdrawn. One of them, the *Conversion of St. Paul* (88), exists in the Balbi-Odescalchi collection in Genoa. In it Caravaggio essayed the conventional, accepted mode of history painting, fancy and dramatically movemented, a manner totally alien to his normal disposition and his current development of style. Perhaps fortunately for both artists, their enforced conjunction was temporary, as was their effect on each other's art.

When we consider the intrinsic classicism in Caravaggio's mature style it may not be too extravagant to think of it, despite his outward attitude toward the High Renaissance, as a kind of Raphaelism refounded in nature (89, 90), of which the classicism, however, shows none of the outward apparatus that would signal its internal presence. But the center of gravity of Caravaggio's style lies nonetheless in a very different place; his style is anchored at a far different depth into reality, and while he endows the ordinary with dignity of both form and emotion he never tries to escape reality or contravene it. And as this art probes more

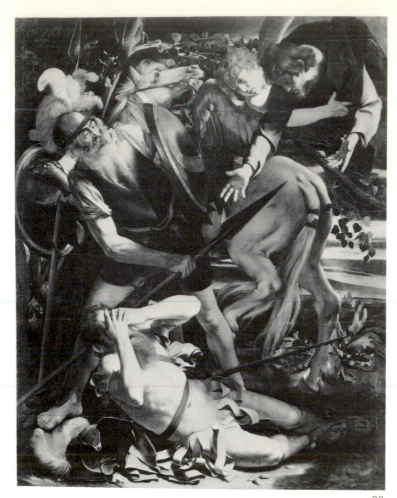

88.
Caravaggio, *Conversion of St. Paul*.
Genoa, Balbi–Odescalchi Collection

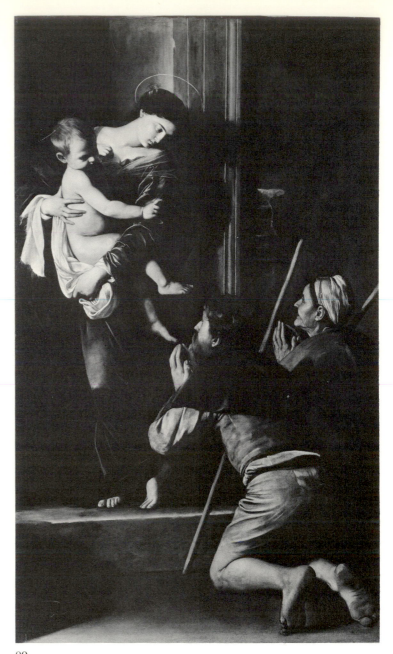

89.
Caravaggio,
Madonna di Loreto.
Rome, S. Agostino

deeply into physical reality so does it come to seek, with ever-increasing profundity, the inner reality of psychological experience. In the *Death of the Virgin* of 1605 (91), in the Louvre, the tenor of emotion, contained and stilled, remains like that of classicism, but it probes in private regions that the conventions of classicism would close off: there is no secret of the psyche that Caravaggio cannot find out. As he searches out the depths of feeling he insists increasingly that it convey a total authenticity, requiring that

90.
Raphael, *Healing of the Lame*
(Tapestry Cartoon), detail.
London, Victoria and Albert Museum.
Reproduced by courtesy of
H. M. the Queen (copyright reserved)

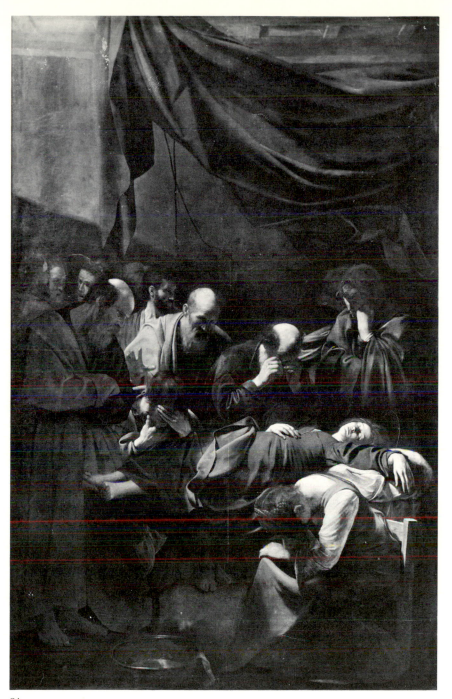

91.
Caravaggio, *Death of the Virgin*. Paris, Louvre

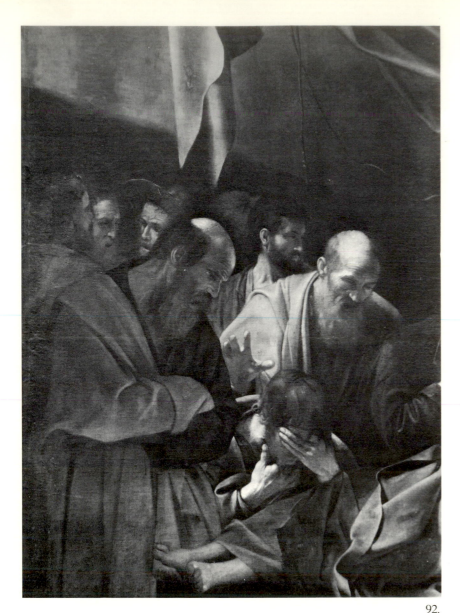

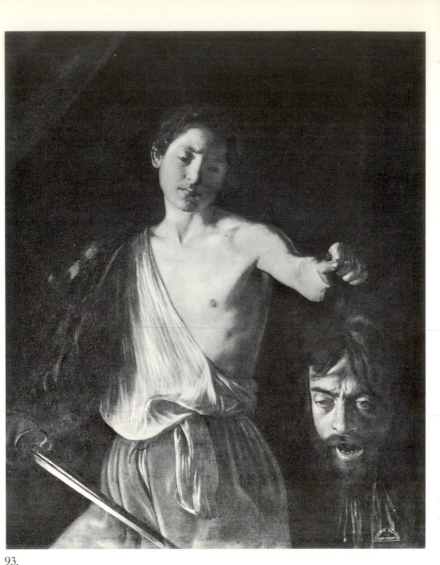

93.
Caravaggio, *David*. Rome, Borghese Gallery

92.
Caravaggio, *Death of the Virgin,* detail. Paris, Louvre

emotion wear the look and carry the behavior of the ordinary world, as different as possible from the styled world of art. In the *Death of the Virgin* the only touch of rhetoric or self-conscious art is in an accessory of setting, in the curtain; the human actors, unrhetorical and styleless, convey in each countenance their absolute veracity of feeling (92). The effect of truth is magnified by the complete absence in the actors of any device or action of dramatic kind. Caravaggio's practice is the antithesis of the rising contemporary doctrine of the rhetorical *affetti,* of which Annibale Carracci at the same time gave such effective demonstrations.

As Caravaggio matures further in the Roman years there

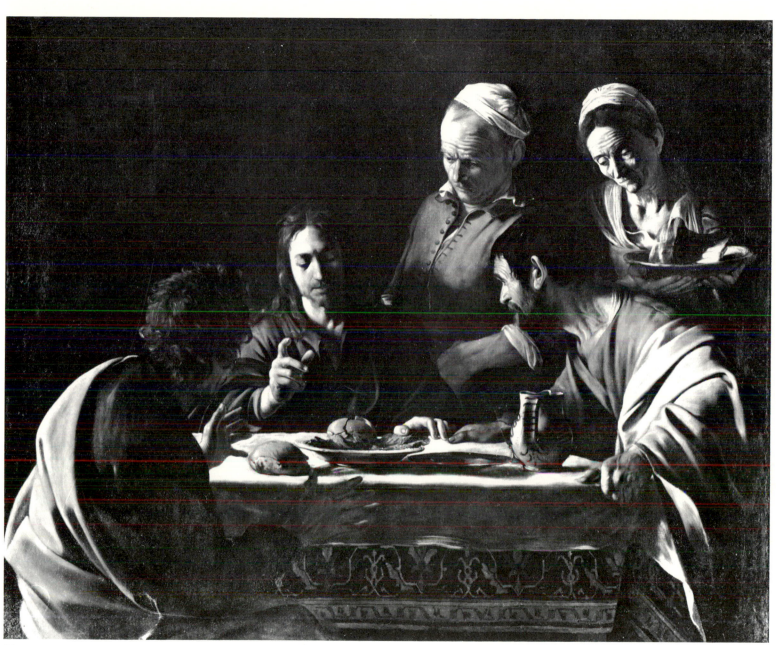

94.
Caravaggio, *Supper at Emmaus*. Milan, Brera Gallery

is an ever-deepening sense in his pictures of the inwardness of feeling. The *David* of the Borghese Gallery (93), of late 1605 or early 1606, tragically introspective, is an example. Late in May of 1606, in an argument that ensued from a ball game, Caravaggio murdered one Ranuccio Tommasini and was compelled in consequence to flee Rome, seeking refuge mainly in the territory of the Colonna princes around Palestrina. It was there that Caravaggio painted a second interpretation of the *Supper at Emmaus* (94), now in the Brera Gallery in Milan; it demonstrates most eloquently what had happened to Caravaggio's perception of emotion in the few years—only four or at most five—since his first version of the theme in 1601–2 (84). In place of the formidable immediacy of confrontation we are offered in the early version, the later painting asks a slower, quieter, more gradual approach to its inhabitants, in whom we find a much more recessive, inward mode of indicating their emotions: a gentling continence controls the tenor of the scene. To support this different tonality of feeling and articulate it, light works with a concomitant restraint. The affective power of the lighting is not actually less than in the brilliant display of the early *Emmaus*: its strength comes, however, not from saliences and contrasts but from an intensely charged yet muted vibration; the light plays more movingly than in the early version, but now in *sordino*.

There may be in this later *Emmaus* painting something biographical, a reflection of a state of mind induced by flight and exile—I hesitate, in Caravaggio's circumstances, to suggest that its motive was remorse. It is true in any case that other paintings apparently of this moment, 1606, show solitary and tragic-seeming states of feeling with extraordinary depth: so the *Magdalen,* which survives only in copies (as in Marseilles; 29), which reveals how well the artist knows the condition of spiritual anguish; or the *St. Francis* (95) in the church of the Cappuchins, in Rome,

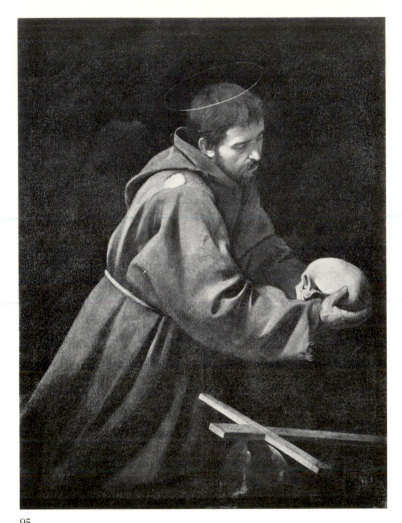

95.
Caravaggio, *St. Francis*.
Rome, Chiesa dei Cappuccini

more controlled, but no less poignant in its record of a state of spirit.

Under banishment in Rome, Caravaggio in the latest months of 1606 or in early 1607 went from Palestrina to

[70]

Naples to work. His experience of that city—violent and teeming, unceasingly in ferment—seems to have regenerated in Caravaggio some part of his own native toughness, redeeming the introversion into which, in the year or so before, he seemed to fall. Objectivity in the record of emotion and explicitness of form are again asserted in the *Flagellation* of 1507 in S. Domenico Maggiore (96). The description of both form and feeling convey the most impactful effect of a veracity, unsparing of the spectator in its acuity and force. In the *Crucifixion of St. Andrew* of 1607 (97), recently rediscovered and now in the Cleveland Museum, the sense of authenticity in the emotions that Caravaggio depicts is such that we must force ourselves to realize that these countenances and gestures are not "records"; they are creative imaginings of the artist, who has felt in himself and then projected on the emotionally inert models what the latter could hardly be expected to feel on command. The feelings Caravaggio pretends to us that he reports are actually his rememberings, interpretations, or extrapolations of his own emotional experience, which he has, in the picture, situated in an externalized reality and instilled into the countenances of real people. Though it is, thus, Caravaggio's emotions that the persons in the picture wear, they seem really to belong only and absolutely to these persons and to the situations in which they act. The *Salome* in London (98), of the same year as the *St. Andrew,* demonstrates this no less certainly. When we consider how intensely Caravaggio must have experienced these feelings it seems a formidable act of art that he was able to extricate himself from his depiction of emotions and externalize and objectify them as he has. There is no commentary from him and no involvement on his part; and there is no index of sentiment or pity, which involvement in situations such as these should almost unavoidably extract.

Caravaggio's objectifying of emotion does not mean a rejection of the compassion that his creating imagination

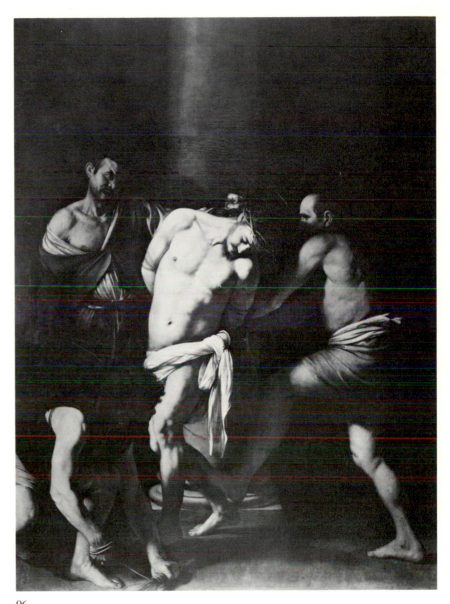

96.
Caravaggio, *Flagellation.*
Naples, S. Domenico Maggiore

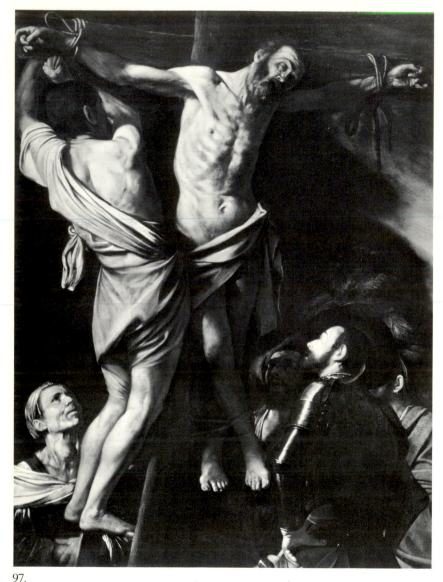

97.
Caravaggio, *Crucifixion of St. Andrew*.
Cleveland, Museum of Art

must have made him feel and that the painted image then demands absolutely from the spectator. It may, however, have been for him a psychological defense. Caravaggio's capacity for compassion was so deep and terrible—in the sense of *terribilità*—that were he not able to objectify it it could have destroyed him. His biography reveals a potency of feeling that repeatedly became ungovernable, erupting in excess, in violence, and, as we have seen, even in murder. What he could not achieve in life, however, he was able to achieve in art, disciplining and objectifying his emotions, sublimating thus his real-life vice of ungovernable passion. The process in art is a self-chastisement and an exorcism; perhaps it might be seen also as a function of his sexual disposition, trying to evade the taint that the "feminine" vice of pity would cast upon his maleness.

When Caravaggio moved on from Naples to Malta late in 1607 there was no interruption in the biographical record of restlessness and violence, but the expression of his art became increasingly controlled. The *Beheading of St. John the Baptist* (99), in the cathedral at Valetta in Malta, of late 1607–8, is the most impressive evidence of this. A truth that, as we look at it in the painting, seems not to have been tampered with at all has actually been stage-managed with a deliberateness like that in a Poussin, a Sarto, or a Raphael. The setting, new in its extent for Caravaggio, is like a dimly lit stage, but it gives no effect at all of artificiality. Instead, it seems to add a wider dimension to the given reality, relating its inhabitants not just to the spectator in the space in front (as was usual before) but to a space that connects at either side into the actual environment, which is at once the actors' and our own. Within this larger ambience the light that reveals the persons and the place to us has been manipulated with precise and absolute control (100): relentlessly, almost cruelly insistent, yet wonderfully fine in modulation, the light works with a matching of powers and subtleties that only Rembrandt

[72]

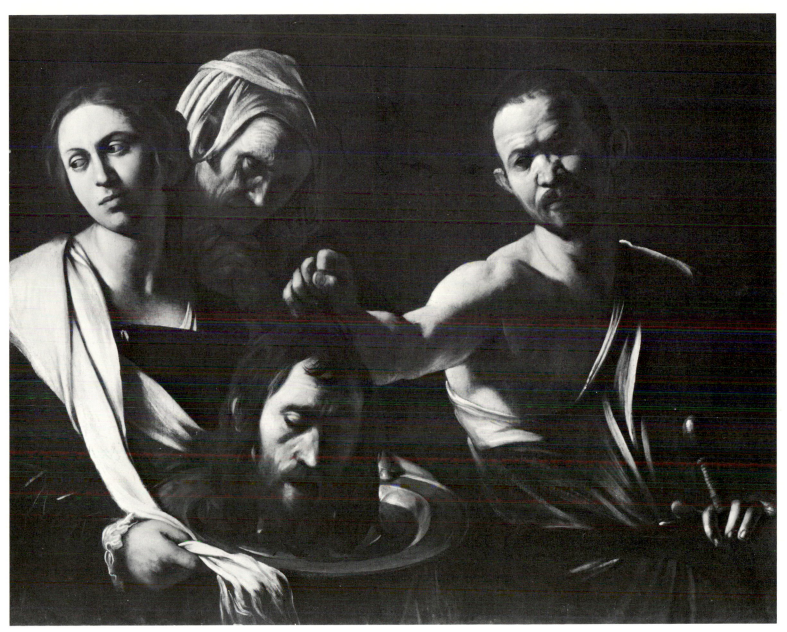

98.
Caravaggio, *Salome*. London, National Gallery

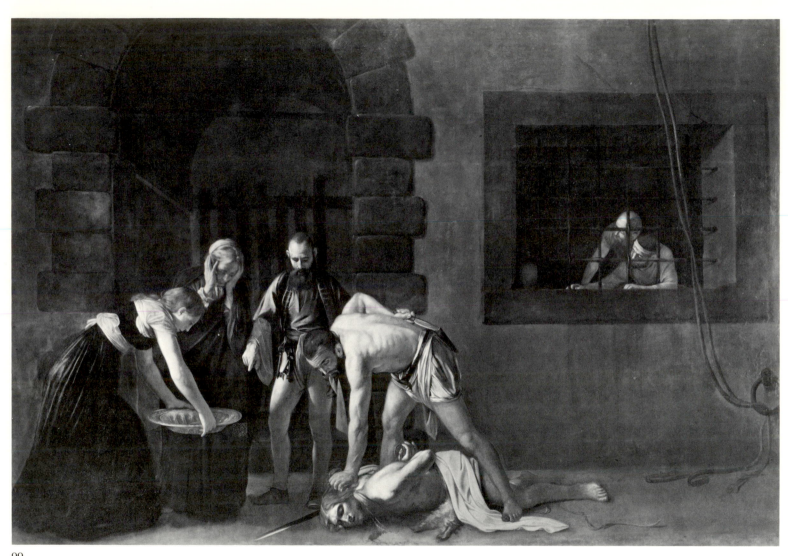

99.
Caravaggio, *Beheading of St. John the Baptist*.
Valetta (Malta), Cathedral

later would achieve, and with an effect of truth that Rembrandt never matched.

The history of the event has been given us in its essentials, but this, even less than earlier paintings by Caravaggio, is not a narrative. We are shown persons—"actors"

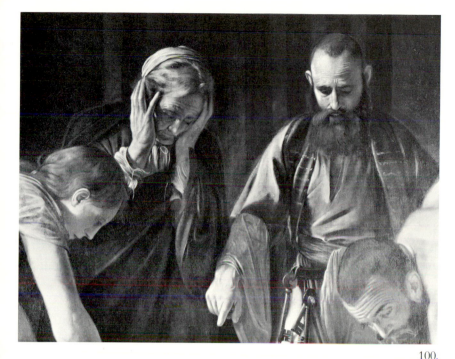

100.
Caravaggio,
Beheading of St. John the Baptist, detail.
Valetta (Malta), Cathedral

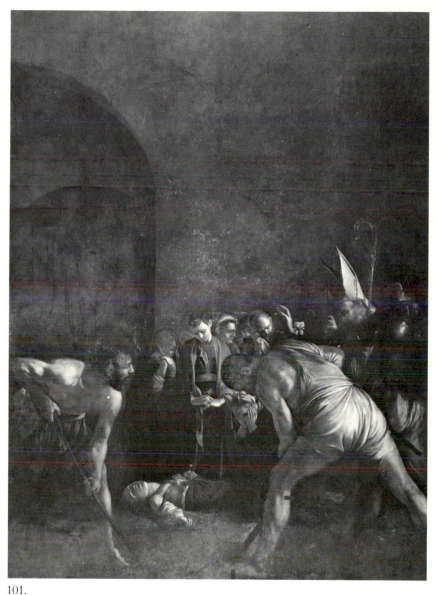

101.
Caravaggio, *Burial of St. Lucy.*
Siracusa, S. Lucia

seems no longer the right word for them—in a situation caught in an arrested moment of which we can feel, oppressively, the stillness: the stillness seems almost to make an aching in our ears. The stillness is that of a crucial pause between violent and dramatic actions, and it is gravid with the sense of them. The violence and drama have not been described, but instead the moment that is the aftermath of one and the prelude to the other. The tonality of this situation is in fact quite contrary to that of drama, especially if we imply by drama something that conveys the sense of being staged. What we have been presented with appears, oppositely, an actuality, a moment of present truth—a

"now"—and, as in the psychological moment of truth the world for a terrible instant of realization stands quite still, so does it here. This past history which has been made a present is a moment of arrested time: by definition, thus, eternal, so that it is no less a "now" for us than for Caravaggio when he arrested it for his contemporaries. And though he has avoided the depiction of the violence, he has made its burden and its consequence of tragedy eternal also.

The *St. John* painting is the image of a death, and in Caravaggio's latest pictures death seems a constant presence—an omnipresence, indeed—hauntingly sensible to the viewer through and all around the human presences in each scene. From the moment of his exile from Rome in 1606, and more after he fled Malta in 1608, an object of vendetta by the knights of the Order, Caravaggio was a hunted man, in fear of violence and death; both soon found him out. The mortal themes of Caravaggio's latest works were surely on account of patrons' orders, but the feeling about death that Caravaggio paints into them is all his own. Done in Sicily, to which he came from Malta, the *Burial of St. Lucy* (101) in the church of S. Lucia in Siracusa dates from late in 1608; the *Resurrection of Lazarus* (102), now in the Messina Museum, from early 1609. Both themes have literally to do not just with death in a general sense but specifically with the grave, with burial and disinterment. Both scenes are inhabited by persons who seem in no way to belong to any world of art but only, simply, to be true, and they carry in them feelings that, no less simply, convey an utter authenticity. The *Burial of Lucy* is so blunt that it is as if in it Caravaggio should have renounced art, wanting to do no more than give mute voice in his canvas to the suffering of a common humanity. In the *Resurrection of Lazarus* the long-past occurrence is relived for us, and we become enchained, transfixed spectators of the real event. The image has the power of a primitive (we

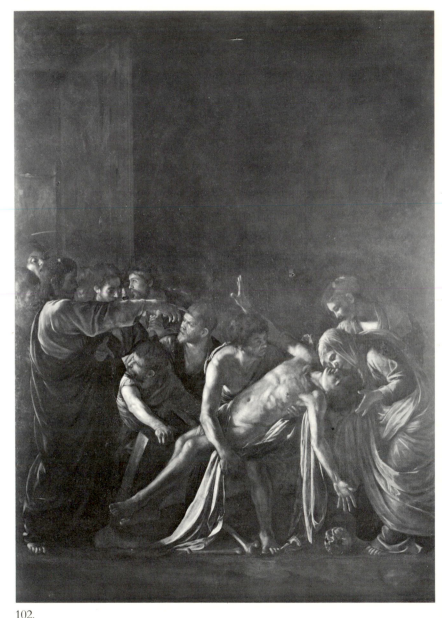

102.
Caravaggio, *Resurrection of Lazarus*. Messina, Museum

103.
Giotto, *Resurrection of Lazarus.*
Padua, Arena Chapel

104.
Caravaggio, *Resurrection of Lazarus,* detail.
Messina, Museum

might compare Giotto's version of the theme; 103), joined, however, to the explicitness that results from a new mimetic truth. As the jolting charge of life assaults him, Lazarus' gesture is like the sudden release of a spring; it brings to mind the Crucifixion and the death that must befall the Christ who here inspires life, as the theme itself implies his resurrection. But there is no sense in these associations of dogma; the absolute meaning is that of the truth, as presence and emotion, of what we have been made to see (104). The *Adoration of the Shepherds* (105), also in the museum at Messina and of the same time as the *Lazarus,* is a similar

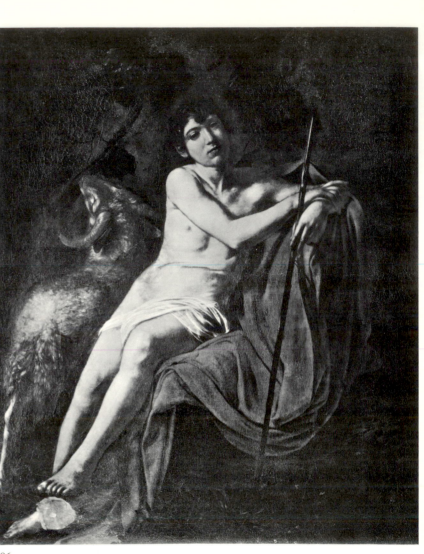

106.
Caravaggio,
St. John the Baptist.
Rome, Borghese Gallery

105.
Caravaggio, *Adoration of the Shepherds.*
Messina, Museum

image of unstyled truth, from which emerges an emotion that is in the same instant completely still and wholly shattering; there is no least trace of subjectivity or sentiment.

Yet a painting I judge to be of Caravaggio's last year, the *St. John* of the Borghese Gallery in Rome (106), done almost certainly in Naples (to which Caravaggio had returned) in late 1609 or early 1610, reveals an evident communion between the artist and his model. The relationship, however, is of a very different kind from that in the pictures of similar subject matter done, like the *Baptist with the Ram* (plate II), in Caravaggio's early mature years. This late image asserts neither physicality nor sensuality; and though its tenor is as gentle as that of the *Musica* (74), earlier than the *Baptist,* this is without sentiment. The late *St. John* speaks of a spiritual dimension in Caravaggio's relation to the model that is unlike what is in the young painter's images of other youths, which are, in one sense, the most private expressions of this artist's psyche. The communion in this late work is a gentle, tragic-seeming one, which knows too well the transience of the mortal world that Caravaggio, more than any painter who had lived so far, had learned to recreate so truthfully in art. Caravaggio's own mortality was proved to him too soon, in July 1610, at the age of thirty-eight.

III

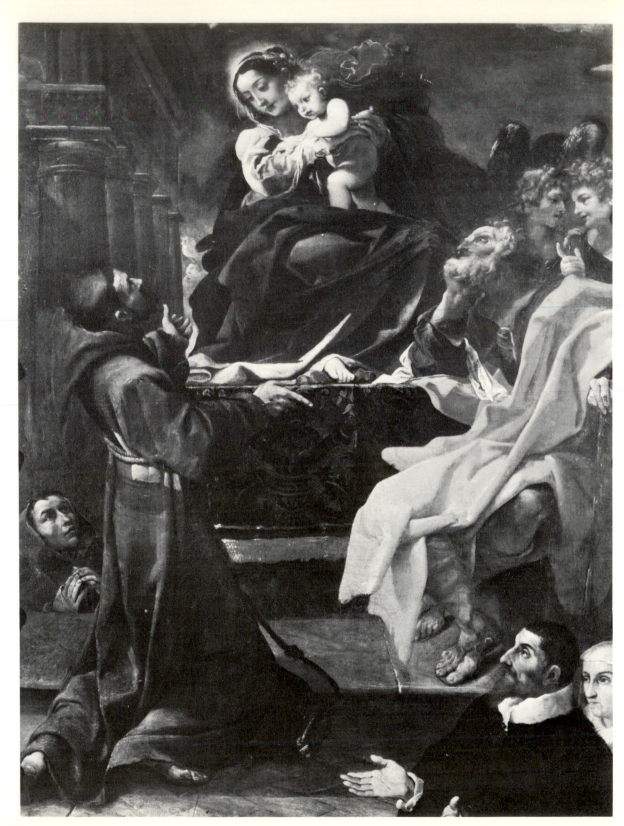

PLATE III.
Ludovico Carracci,
*Holy Family with St. Francis
and Donors.*
Cento, Museo Civico

LUDOVICO CARRACCI

LUDOVICO CARRACCI WAS the oldest of the family triumvirate of Bolognese artists—Ludovico himself, born in 1555, and his two cousins, Agostino and Annibale—who altered drastically and irrevocably the course of Italian art in the later years of the sixteenth century and laid the bases for the style that would dominate the century to come. Ludovico is outdistanced in art history by his cousin Annibale, five years his junior, whose creativity knew virtually no impediment, at least until his latest years. Ludovico was nevertheless in his own right an artist of extraordinary stature, the inventor of a novel rep-

ertory of feelings, and forms in which to communicate them, that would open ways to the coming Baroque style. Yet this very capacity for feeling in Ludovico was also his defect. Quite without the classicizing resource of emotional control that Annibale possessed, Ludovico's powers of feeling could simultaneously be the motive of his accomplishment and the cause of grave flaws in it. He was a faulted genius who needs more elaborate explanation than we can here afford. I shall make some observations only, passing many matters of importance without remark: my account will of necessity be incomplete.

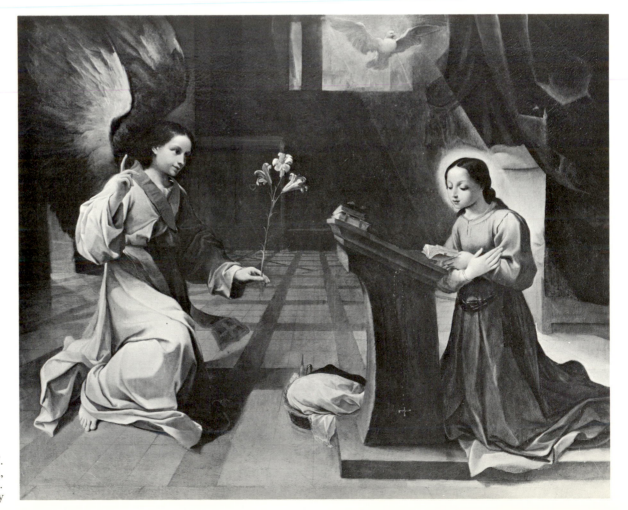

107.
Ludovico Carracci,
Annunciation.
Bologna, Gallery

The *Annunciation* (107), now in the Bologna Gallery, is the earliest painting that we can attribute with complete certainty to Ludovico. The date given it in the literature varies between 1582 and 1584. It is regrettable that the date cannot be more exactly specified, for our interpretation of a matter of historical precedence between Ludovico and Annibale in part depends on it. Ludovico was by this time twenty-seven years old at least and had been a member of the painters' guild since 1579.

Let us see what this early work tells us of the painter. It is quiet, even gentle, in form and in expression, yet despite this quiet we feel a very powerful, assertive presence. The form impresses itself on us by its clarity and simplicity, and it is made salient by a strong, uncomplicated light. The image creates an immediate and adequate effect of truth, not only in its presences but in the communication of their meaning by action and gesture; the seeming naturalness of action and gesture has an effect as intense as the form itself, conveying genuinely the actors' inner states.

How did this painting differ from—or resemble—its contemporary context of Italian art? Let us compare, first of all, a picture probably of some ten years earlier by Ludovico's teacher, Prospero Fontana, an *Annunciation* now in the Brera Gallery in Milan (108). The Ludovico stands against this representative work of the late Maniera as an index of a new attitude toward the nature and the uses of art, and indeed toward nature itself. In the Maniera work ornamental value takes primacy over the desire for descriptive truth, and a code of highly stylized, fancy behavior almost excludes the sense of any narrative sincerity. Ludovico's picture seems, by comparison, to be deliberately in a prose style while the Maniera *Annunciation* pretends to a fanciful and elaborated poetry.

Another work exactly contemporary with Ludovico's *Annunciation,* by an older, highly distinguished Bolognese painter, Bartolommeo Passarotti, is a *Presentation in the*

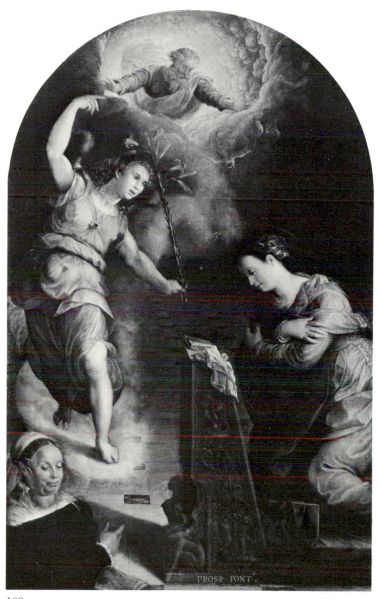

108.
Prospero Fontana, *Annunciation*.
Milan, Brera Gallery

Temple of ca. 1583, now in the Bologna Gallery (109). It is apparent from this painting that in the Bolognese school around Ludovico, even among older painters, there were strong symptoms, though they are no more than symptoms, of an interest like his in forceful presence and descriptive truth. But Passerotti's naturalism, unlike Ludovico's, is fragmentary, and in the context of the whole picture the elements of naturalism are overridden by the ornamentalism, the attitudinizing, and the concettistic fancy of Maniera.

The concern with a new naturalism of forms and content and, as a necessary consequence, a new mode of actual compositional design was not unique to Bologna at this time: it had been anticipated elsewhere in Italy, and most particularly in Florence, a decade before Ludovico's *Annunciation*. By this date in Florence, a naturalizing style was much advanced and in some respects in command of more sophisticated means than Ludovico possessed. However, as in the *Doubting Thomas* by the Florentine Santi di Tito (110), datable before 1584 (in Borgo San Sepolcro), we realize that the Florentine impulse to naturalism is impeded by a residual Florentine habit of ideality, and by a politeness that inhibits seeking for intensity. At the same date there are also Roman evidences of the new tendency toward naturalizing style. The *Immaculate Conception* by Scipione Pulzone (111), in the town of Ronciglione near Rome, ca. 1581, reveals an accomplishment of naturalistic form that very much resembles Ludovico's in its insistence; however, it is more constrained, reflecting more the role that was played in Rome by the mentality of the strictest Counter-Reformation.

But it is in the work of Ludovico's cousin, the young Annibale Carracci, as in his *Crucifixion* of 1583 (plate I), that we observe a measure of attainment of naturalism in painting that far outstrips all other contemporaries. Beside this work, the naturalism of Ludovico's *Annunciation* seems

109.
Bartolommeo Passarotti,
Presentation in the Temple.
Bologna, Gallery

110.
Santi di Tito,
Doubting Thomas.
Borgo San Sepolcro, Cathedral

111.
Scipione Pulzone,
Immaculate Conception.
Ronciglione,
Chiesa dei Cappuccini

incomplete and arbitrary, more like the mode we have just observed of the contemporary Pulzone in Rome, or like the restrained assertions of descriptive truth we find in Florentine reformers like Santo di Tito. Annibale here displays a far more—in every sense of the word—*comprehending* grasp of the visual matter that signifies existence: complex, flexible, and alive. Whatever Ludovico had accomplished by this time in the way of a naturalism like Annibale's, his penetration on this way was much behind.

The *Vision of St. Francis* (112), now in Amsterdam, is a picture by Ludovico of slightly later date than his *Annun-*

ciation, probably between 1583 and 1585; evidently it is a more confident and sophisticated work. It is more searching and elaborate in its description of forms, especially as they are revealed in light. There is a continuing constraint in the demeanor of the actors, but their setting and the composition that contains them have a new freedom. There is the evidence here of the working on Ludovico of Annibale's more advanced naturalist example and of their joint exploration of their program of what is historically called eclecticism, of reference to the great masters of the earlier sixteenth century: Correggio in particular has been

112.
Ludovico Carracci,
Vision of St. Francis.
Amsterdam, Ryksmuseum

114.
Alessandro Moretto,
Madonna di Paitone.
Paitone, Chiesa del
Pellegrinario

113.
Correggio,
Nativity (La Notte).
Dresden, Gallery

important to the *Vision of St. Francis.* To compare it to Correggio's famous *Notte* (113) is to observe that there are, there, a similar compositional mobility, a like spatial movement, and the source of inspiration for Ludovico's various and highly expressive manipulation of the light. And Ludovico's fineness and intensity in the description of his actors' expressions is no less Correggesque. As in Correggio also, light articulates feeling, defining and most subtly specifying it. At the same time, the quiet of larger forms contains emotion and creates a tension between intensity of feeling and its constraint, which generates an extraordinary poignance of effect. There is recall not only of Correggio but of the forms and modes of natural description and of simple and sincere belief that occur in another aspect of the North Italian tradition, more provincial than the Bolognese, as in the Lombard *Madonna di Paitone,* about 1550, by Moretto (114).

The feeling in Ludovico's picture is of controlled yet profound piety. It has been noted often that this image conforms to the prescriptions for the renovation of religious art that are contained in the tract referred to earlier in connection with Annibale, the *Discorso intorno alle imagini sacre e profane* of Cardinal Gabriele Paleotti, which recommends the union of piety with descriptive truth to move the Christian spectator. The first two chapters of the tract were issued, though not for general distribution, in late 1581 with an imprint date of 1582. The near-coincidence of time, place, prescription, and practice between Ludovico's first two pictures and the *Discorso* are too close to be only accidental. It is possible, or even likely, that a reading of Paleotti, or a discussion of it, gave an affirming impulse to a direction Ludovico had already undertaken; we might suppose that something similar might have occurred in Annibale's case as well. But the connection with Paleotti's tract is imprecise, and many questions about it are unanswered. For example, how, within a year, or perhaps less, of the appearance of the partially published book, could a major *leap* of style have been evolved from its prescriptions—from the modest reform it seems the tract proposes to formidable invention? Paleotti, after all, gives only verbal advice in his *Discorso* but no visual model, and we have seen that his own artistic taste was far less radical than the style that either Ludovico or Annibale conceived. Paleotti did not invent Ludovico's or Annibale's style, and he may not at all have meant his verbal prescriptions to take the form that, hypothetically, the two artists gave them.

What must be clear in the matter of Ludovico's and Annibale's innovation of style is Annibale's far more radical exploration of naturalist devices. If we may deduce from this that it was he who set an example to Ludovico for this naturalist direction, it further vitiates the possible role of Paleotti's treatise in forming Ludovico's style. We have noted that the early Annibale's pursuit of naturalism is not only in religious subjects, where Paleotti recommends it, but in genre, a region that much more immediately invites it and that Ludovico never chose to explore. Let us review a few examples of this naturalist direction in a genre realm: antecedent to the S. Niccolò *Crucifixion* (plate I), Annibale's *Butcher's Shop* (12), most probably of 1582, at latest 1583, or, slightly after the *Crucifixion,* the *Bean Eater* of the Colonna Gallery in Rome (15), of 1584–85. We remarked that Annibale had even very early dared to handle a religious subject as if it were genre, in his *Dead Christ* (11), now in the Stuttgart Gallery, painted no later than 1582 or 1583.

I think we may recapitulate the order of events in these first essays toward the new naturalism that would be a basic factor in the founding of the "modern," post-Mannerist style. The first and only partial steps would have been taken by Ludovico in concert with, and partially in echo of, contemporary reformers, partially in Bologna, more particularly in contemporary Florence; but Ludovico himself did not move much beyond the example of these contemporaries, if at all. His action, however, could have been a stimulus to the younger Annibale who then, plunging radically ahead on this route, outdistanced Ludovico and then in turn gave him example in the new direction.

The dating of Ludovico's first large-scale altarpiece (115) varies between 1585 and 1588. It has now found its way to the museum in Raleigh, North Carolina. If we grant, as we seem to have done, Annibale's primacy in the invention of the new naturalism, then this work by Ludovico must owe much to Annibale's precedent in his *Assumption* of 1587 (30), now in Dresden. Annibale's (as one might call it) "populist" naturalism of types and countenances is reflected from the Dresden altar into Ludovico's painting, and there is a partial, less successful adaptation of Annibale's naturalism of gesture and of action. Ludovico's modernist intention here has, however, been compromised with a residual

115.
Ludovico Carracci, *Assumption of the Virgin*.
Raleigh, N.C., Museum of Art

rigidity of forms like that which appeared in his earlier paintings, as well as by a conception of the figures that is, in the most literal sense, superficial more than it is substantial: in a way that recalls tendencies of past Mannerism, the figures wear garments that seem assemblages of colored planes, with very little matter underneath. The spatial scheme is also recollective of Mannerism, conspicuously of precedents in Tintoretto.

A *Conversion of St. Paul* (116) in the Bologna Gallery, of between 1587 and 1589, is a religious painting that has more the character of an ancient history than of a devotional image, and it summons from Ludovico much more of the Mannerist residue that is in his present disposition. This is a potentially fancy subject, like the preferred subjects of the Mannerists, and it invites elaborated ornamental contours and fine attitudes and even a specific reference to a precedent then in Bologna for this same theme by the great Mannerist painter Parmigianino. This mannerizing tendency is not just an overcast on the style of Ludovico's picture but a significant factor in it. It is, however, less assertive in the whole effect of style than the still further accommodation Ludovico has now made with Annibale's example of a new direction, specifically again in the Dresden *Assumption,* of physiognomic description and insistently dramatic action. And the effect of presence and of drama is once more magnified by the instrument that Ludovico employed so well from the beginning, his skillful manipulation of light.

When he was a student Ludovico had been called "il bue" for his apparent slowness. He was indeed slow to mature if we conceive that the *Bargellini Altar* (117), painted by Ludovico in 1588 at the age of thirty-three, is the evidence of his first emergence into an entirely self-certain and commanding style. The style is a dialectic of the rigid, still abstracting surfaces that we found in the earlier *Assumption* and of the ornamental fluency of shapes and design that

116.
Ludovico Carracci, *Conversion of St. Paul*. Bologna, Gallery

117.
Ludovico Carracci, *Bargellini Altar*. Bologna, Gallery

were in the *Conversion of St. Paul:* both, it should be noted, Maniera-like. To previous retrospective study in the domain of Correggio, Ludovico now has joined Titian and Veronese, perhaps come to Ludovico from Annibale's exposure to the Venetians *in situ* rather than from an internal impetus of Ludovico's own. Annibale's *St. Matthew* (34), also dated 1588, is unequivocally related to Ludovico's current work, but the evident connection between the two altarpieces also marks their difference. In Annibale's the forms are fleshed and rounding, sensuously textured, and they are traversed by rhythms that are suave, controlled, and strong, closely approximating the examples of earlier sixteenth-century Venetian design. Ludovico, however, still makes angled planes of form as if from sheet metal; contours are less curves than they are sequences of fine-edged angles, impelled and nervous in their rhythms. They lend an overcast to single forms and to the whole design of a transposed nervous Maniera elegance. This effect is accompanied, and at once moderated and modulated, by the working of the light; very differently from Annibale, Ludovico's light makes fine, almost febrile complexities of chiaroscuro and then, contrarily, as if in compensation, makes episodes of textured radiance which almost outdistance Annibale in their warmth.

The *St. Vincent* (118), of slightly later date, probably 1589–90, in the Palazzo Magnani in Bologna, is in the same temper of form and draftsmanship as the Bargellini altarpiece, nervous and fine-spun; the elegance of design and shapes is still more recollective of Maniera. There are here, again, episodes that specifically derive from Parmigianino. But still more evidently than in the Bargellini altarpiece these elements are wedded to a sharply descriptive and powerfully presence-making "modernity." Color functions similarly; its sharpened and insistent brilliance, assertive and light-saturated, on the one hand conveys an

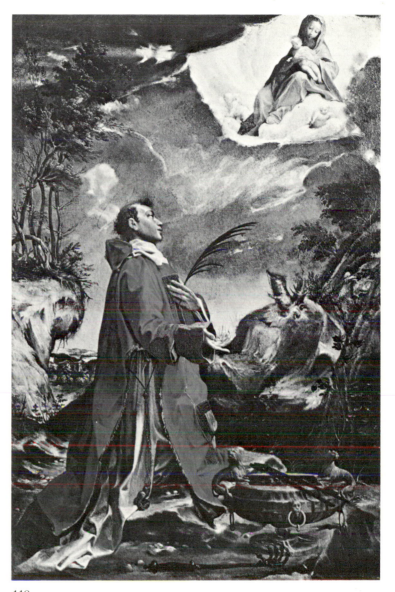

118.
Ludovico Carracci, *St. Vincent.*
Bologna, Palazzo Magnani, Credito Romagnolo

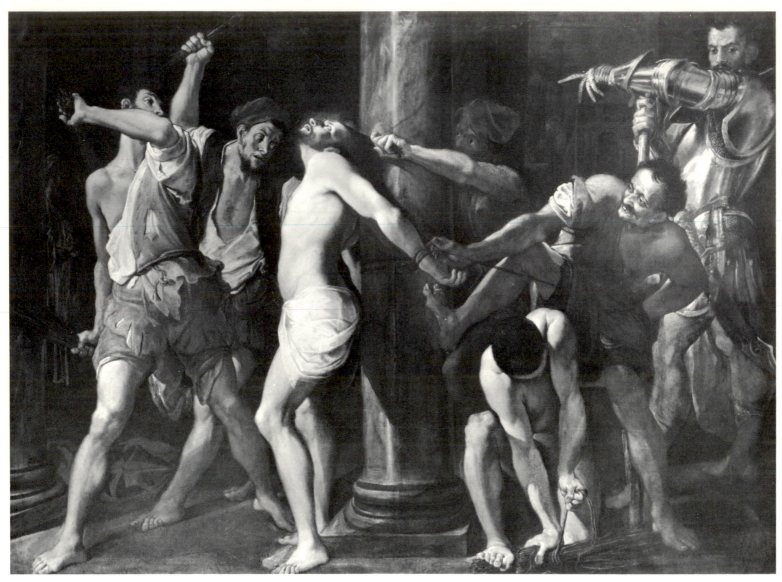

119.
Ludovico Carracci, *Flagellation*. Douai, Museum

abstracting ornamental value and on the other holds a powerful descriptive force.

The *Flagellation* (119) in the museum at Douai, of 1589–90, shows the same vocabulary of form, which has been applied now not to elegance but to the illustration of acutest pathos. Ludovico's response to the narration and its content of emotion is an assimilation to it in an act of sharpest empathy. The symptoms of this exceptional capacity for feeling were present in the earliest works, but there it had been muted, inward, and constrained. Here that potential for feeling has been intensified to an incisiveness and pitch that make a major invention without precedent in the history of Italian art and with no exact previous counterpart elsewhere. Ludovico's concern with the expressive possibilities of light and his capacity to manipulate it, visible since his beginnings, are here also developed to a new degree, forced so as to illustrate the sharpness, poignance, and violence of the emotion. The light works in reciprocally magnifying conjunction with the taut, wire-sharp, swift-moving web of rhythmic pattern. May one speculate that if Caravaggio saw this work on his way to Rome about this time it could have had a considerable effect on him, perhaps more potent than that of his Milanese teachers? The *Capture of Christ* (120) is in the same mode, but with its communication made still more emotionally acute by the knotting intersections of the actors with each other and by the closeness of presence, pattern, and emotion to

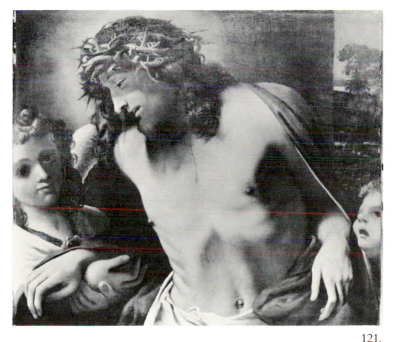

121.
Annibale Carracci, *Man of Sorrows*.
Dresden, Gallery

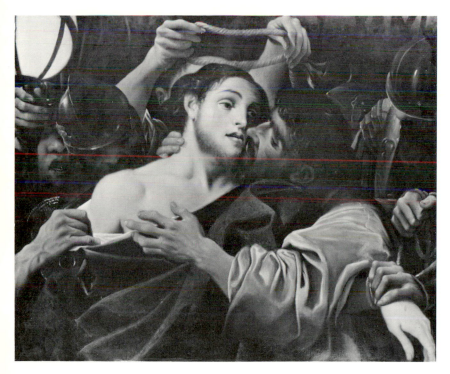

120.
Ludovico Carracci, *Capture of Christ*.
Paris, private collection

ourselves. In Annibale Carracci's painting of a similar theme (121), in Dresden, of two or three years before, the sense of nearness may be even more and the pathos no less strong, but it is conveyed to us with a very different sense of its control. Ludovico's power of emotion is his great resource: his aggressive exploitation of it is at once his prodigious merit and his potential failing.

The *Madonna and Child with Saints* of about 1590–91 (122), in the Doria Gallery in Rome, indicates how Ludovico adjusts his mode to the inherent tenor that he discerns in the subject matter. This intimate and loving theme calls forth a more fluent, less nervously complicating rhythm, and a warmer, richer, more sensuously textured surface. Color and light modulate into one another. It is not just a different theme that calls forth this response, but also Ludovico's reaction to Annibale's example, increasingly more pressing and authoritative in the last two years, of a Venice-like luxury and suavity of surfaces and of form.

This impulse toward a more sensuous and fluent style had been received, to begin with, from Annibale, and then, in the altarpiece of 1591 (plate III) for the Cappuchin church at Cento, near Bologna (now Cento, Museo Civico), was put into what we may call the crucible of Ludovico's extreme emotionalism, from which it emerged something different in degree and effect from what Annibale had meant by it, become the instrument of a now almost violent splendor of emotion and of form. In the Cento altar, life-sized, grand, rich-textured presences are powerfully moved. They emerge from the unifying ground in radiant assertions of their light and color. The light seems the great animating instrument in the picture, at once the symptom of the emotional exaltation—it is almost a possession—the artist has conceived for his actors and the agency of its expression. This is a picture of sensationally Baroque effect, far more so than any to this moment in Annibale's oeuvre, and it anticipates by a genera-

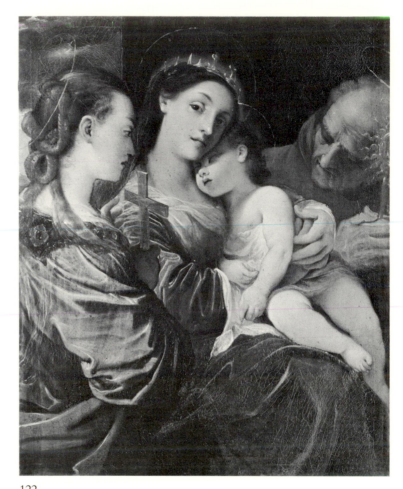

122.
Ludovico Carracci, *Madonna and Child with Saints*.
Rome, Doria Gallery

tion the character of the incipient High Baroque; and located in Guercino's native town, this picture would in fact become the younger artist's school. But even as it looks forward, the Cento altar has, in characteristic Carracesque way, looked back to find inspiration for its forward impetus, to Correggio, whose example has here been read

123.
Correggio, *Rest on the Flight to Egypt*
(*Scodella Altar*). Parma, Gallery

124.
Correggio, *Madonna of St. Jerome*
(*Il Giorno*). Parma, Gallery

in the originals, not just through Annibale's paraphrases. Compare the richness and mobility of the *Scodella* altar (123) or the passionate expressiveness of the great *Giorno* (124), both readily accessible to Ludovico in 1591. The *Trinity* in the Vatican Museum (125), of around 1591–92, holds another element like that in the High Baroque. In it

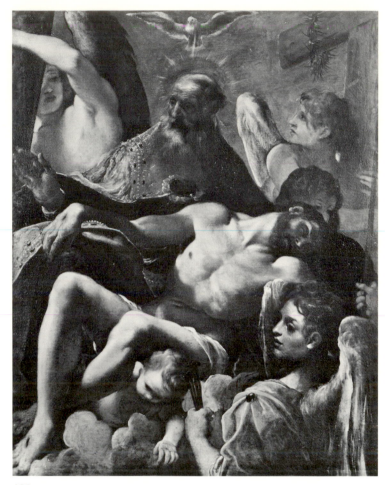

125.
Ludovico Carracci, *Trinity*.
Vatican Gallery

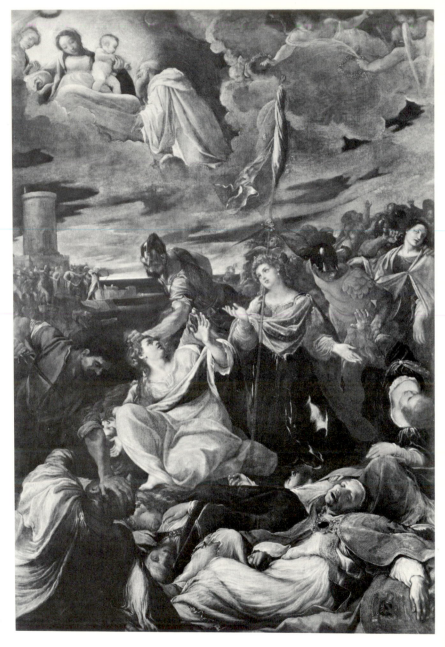

126.
Ludovico Carracci, *St. Ursula Altar*.
Bologna, Gallery

the light is the vehicle not of an emotional exaltation but of a grand pathos, which, as in the High Baroque, is conveyed through and fused with beauty of a sensuous presence.

The *St. Ursula Altar* (126), in the Bologna Museum, of 1592, applies the mode of the Cento altarpiece to an extended tragic narrative. Light is again the agent that articulates what is narrated and described, and it conveys the tenor of emotion; darkened and various, intrinsically dramatic, it reveals tragedy and beauty simultaneously. This, too, is a modus of the High Baroque and one that as well looks backward to Correggio. But there is a further retrospective dimension here, identifiably Venetian, which mixes Titian's luxury of color with the complexity of Tintoretto's composition.

Like Annibale, Ludovico does not simply practice a style; within his style he practices what we have called modalities, adjusting style in each instance to the nature of the subject dealt with. The *Madonna with St. Jerome and St. Francis* (127), the so-called Scalzi altar, of ca. 1593, also in the Bologna Gallery, is not a narrative subject but a visionary, devotional, and dogmatic one, illustrating the Immaculate Conception. Light here has been muted to a pale shimmering of the upper air. The impulsive, rounding rhythms that had been in the Cento altarpiece and its assertive sense of substance are preserved only in St. Jerome; the Virgin and St. Francis are more fragile beings, recalling in their forms the rhythmic patternings of the Bargellini altar. The emotional sense of the picture is undeniably grand, yet restrained and finely tuned. It is a deliberately distilled image, obviously recollective of Raphael's *Sistine Madonna* (39), but, in contrast, it shows none of the essential serenity of that great classical work. Here the feeling is of febrility contained, and of the imminence of an extreme emotion. This is the final confirmation of divergence of Ludovico from Annibale's example, in an unclassicizing

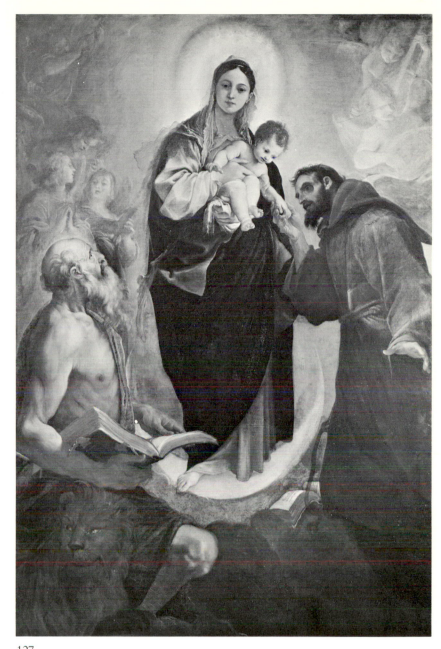

127.
Ludovico Carracci, *Madonna with St. Jerome and St. Francis (Scalzi Altar).*
Bologna, Gallery

direction that contrasts with Annibale's powerful affirmation, in his altarpiece in Bologna (42) of the same moment, 1593, of a resurrected genuinely classical style.

In 1594, in the *Vision of St. Hyacinth* in the Louvre (128), the essential emotional personality of Ludovico suddenly emerged. Hitherto it had been somewhat deflected or restrained, or perhaps it was not till now entirely matured. But here we see it in its full dimension, impassioned, extreme, and wholly counter-classical. The power of magnified presence achieved recently at Cento is, in this work, pressed toward the spectator in a crowded space. Strong physical movements by the actors are incorporated with violent impulses in the design. The vision depicted for us of the Saint's own vision has been given intensest immediacy and violent life, of which the extreme degree is concentrated in the head and hands of Hyacinth. There is no face like it in the history of art before. A surreal straining toward ecstasy, striving, in the literal sense of ecstasy, beyond the self, is frozen rigid in this state, harsh and utterly unforgettable. In the pendant life-size paintings of 1594–95 of the *Flagellation* (129) and the *Crowning with Thorns* (130), in the Bologna Gallery, a like violence of feeling has been incorporated into dramatic actions that have been interpreted by Ludovico with every device he could conceive to intensify their drama. Powerful anatomies and postures not only narrate their drastic and impulsive movement; the very patterns of their movement, sharp, urgent—indeed explosive—convey the passions that inspire them, and the tenor of violence is increased and complicated by the light. All this explosion, of forms and feelings, bursts upon the spectator in life size; again there is the implication of a Baroque style. By comparison, Caravaggio's scenes of violence seem, and are, stylized and classically controlled.

The *Transfiguration* in the Bologna Gallery (131), commissioned in 1593 but painted in 1594–95, is of over-life-size scale, about five meters high. In it the concentrated

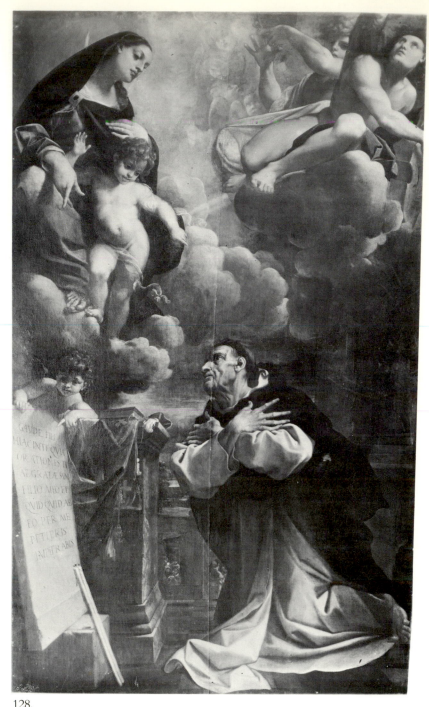

128.
Ludovico Carracci, *Vision of St. Hyacinth*. Paris, Louvre

[98]

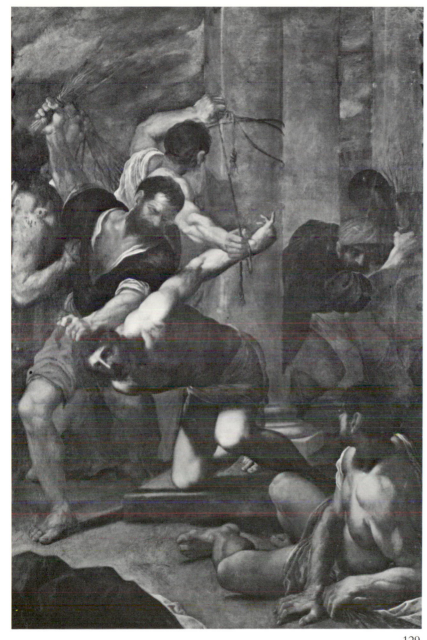

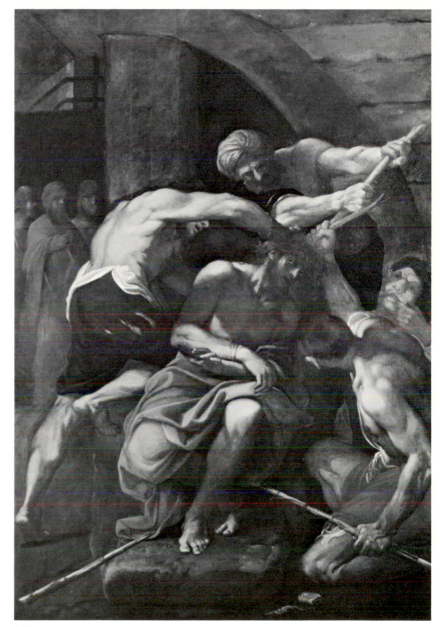

129.
Ludovico Carracci, *Flagellation*. Bologna, Gallery

130.
Ludovico Carracci, *Crowning with Thorns*. Bologna, Gallery

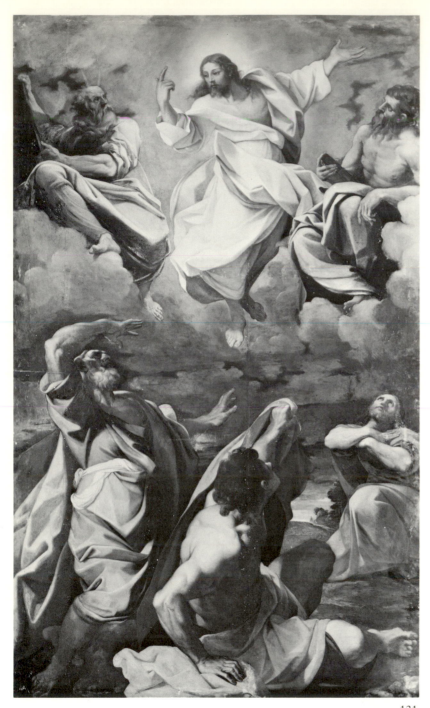

131.
Ludovico Carracci, *Transfiguration*. Bologna, Gallery

drama of the *Flagellation* and the *Crowning with Thorns* is magnified into grandiose hyperbole. The picture exaggerates in virtually every respect, in the gigantism of anatomies and the superabundance of their draperies, in the excessive action and in gesture which is more than operatic, all of these reinforcing the effect the figures make of sheer overpowering physical presence. The picture hits the spectator with prodigious force. Yet, for all the overpowering physicality in the *Transfiguration,* its whole effect is different from the *Hyacinth.* Here there is a stylization of gesture and action that is rhetorical in its effect, and an artificiality in the compositional order that makes this seem a staged rather than a true event. Above all, there is an artificiality in the color, strong but cold, isolated into local fields—cherry red, cobalt, yellow-gold, and white. The Baroque-like devices seem here to coexist with impulses of rhetoric and artifice that have reasserted themselves from the previous Mannerist style. Ludovico's inspiration is at least in part from Annibale Carracci's first narrative altar on very extensive scale, the highly rhetorical and dramatic *History of St. Roch* (48), now in Dresden, begun earlier, about 1587–88, but finished—perhaps with the help of Ludovico himself—contemporaneously with the *Transfiguration,* around 1595. This hyperbolic mode is an inflation and an unclassical exaggeration of what had originally been a classical grand manner, but it is also a means of achieving the rhetorical purpose of persuasion of a popular religious audience, in a way that was to become frequent and familiar in the Baroque style. This mode became the one which Ludovico thought appropriate to his large-scale commissions, as of narrative altarpieces, for a decade or more.

The *Apostles at the Tomb of Mary* of 1601 (sometimes called the *Assumption of the Virgin;* 132), in the Church of Corpus Domini in Bologna, lessens by a degree, but by a degree only, the extreme action of the *Transfiguration,* but

132.
Ludovico Carracci, *Apostles at the Tomb of Mary*.
Bologna, Corpus Domini

133.
Ludovico Carracci, *Christ's Descent into Limbo*.
Bologna, Corpus Domini

to compensate for this there is an increase in the complexity of the picture, in the lighting and in the design in general; and there emerge in this altarpiece certain idiosyncrasies of form and of expression—queernesses, indeed—that are eccentric spinoffs from Ludovico's insufficiently controlled emotionality. They are visible in the *Apostles at the Tomb* and in the *Descent into Limbo* (133), a pendant picture in the same church, painted a few years later, in 1604–5; both show a tendency toward unnatural elongation of the figures and abstractness in the drapery style, flatter and stiffer in its patterning than before, suggesting—yet again—some partial recall of the late Maniera. At the same time, as in the *Calling of Matthew* (134), in the Bologna Gallery of 1605–7, there is a way of describing physiognomies in these altarpieces that verges on caricature. The tendency to caricature relates to contemporary ideas of realism, and specifically to the notion of what we have previously called "populist" illustration; but at the same time the degree of Ludovico's caricature exceeds our sense of what is plausible. The *Calling of Matthew,* by the way, is the only evidence of an effect on Ludovico of his brief and apparently grudging visit to Rome in May and June of 1602: the gesture of the Christ is an echo of the famous gesture, ultimately Michelangelesque, in Caravaggio's picture on this theme.

The deformations and the eccentricities we have noticed in the altarpieces painted in the hyperbolic mode are completely willed and purposeful. This is very evident when one observes the quite contrary character, strongly idealized in a classicizing vein, of a picture produced close in time to the *St. Matthew* altar, the *Empress Visiting St. Catherine in Prison* (135), in the Church of S. Leonardo in Bologna, of about 1605–6. That the mentality that takes these descriptive liberties, either idealizing as here, or eccentric as in the *St. Matthew* altar, has an affinity still with the past Maniera is confirmed by the character of design Ludovico

134.
Ludovico Carracci, *Calling of Matthew*. Bologna, Gallery

135.
Ludovico Carracci, *Empress Visiting*
St. Catherine in Prison. Bologna, S. Leonardo

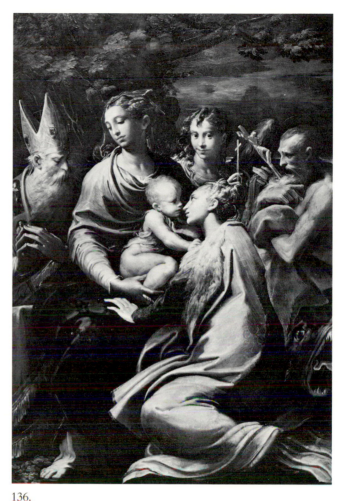

136.
Francesco Parmigianino, *Madonna of St. Margaret*.
Bologna, Gallery

has found for his painting. It is made of fine ornamental convolutions that would be quite acceptable to the author of such a wholly Maniera picture as, for example, Parmigianino's *Madonna of St. Margaret* (136), in Ludovico's time (and still) in Bologna.

[103]

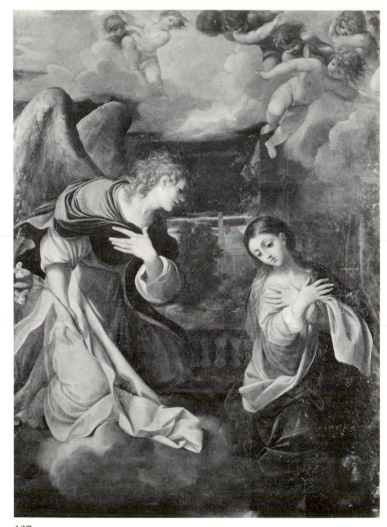

137.
Ludovico Carracci, *Annunciation*.
Genoa, Palazzo Rosso

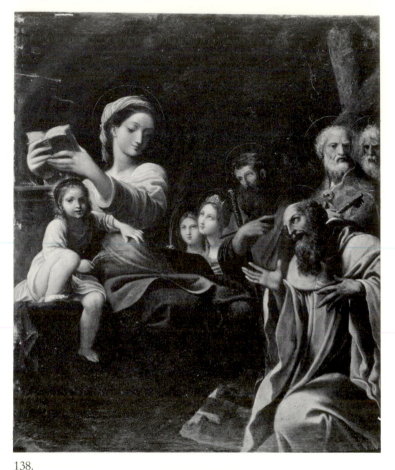

138.
Ludovico Carracci, *Madonna with Saints*.
Bowood (Wilts.), Earl of Shelburne

An arbitrary attitude toward description is stronger still in a contemporary painting, the *Annunciation* (137), in the Palazzo Rosso in Genoa, of 1605–7; so also is the sense of an affinity with the precepts of the past Maniera that make ornament a value that takes precedence over truth. It is not only description that is absorbed here into ornament; in an analogous process, emotion turns from prosaic verity into

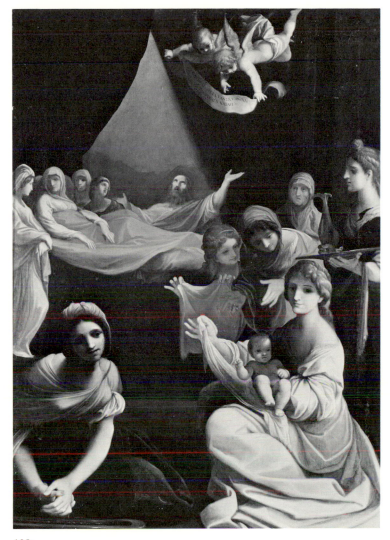

139.
Ludovico Carracci, *Birth of the Virgin*.
Bologna, Gallery

something ornamental, deflecting force of feeling into sentiment; yet sentiment too, despite its sweetness, is intense. We have long since observed that Ludovico was a convert to his cousin's naturalism but not its inventor. Ludovico has apparently decided—he is in his forties now—that naturalism is no longer primary or vital to his intentions for his art.

The *Madonna with Saints* in the collection of the Earl of Shelburne (138), of around 1607, and the *Birth of the Virgin* in the Bologna Gallery (139), of 1607–9, give evidence of the extraordinary measure of artificiality that Ludovico now permits himself. Here are purities of form that are quite pseudo-classical in their effect, which strangely coexist with distortions that suggest caricature. Works like these by Ludovico—and there are a number of them—may be taffy in their forms and confectionery in expression; they may be, in our perspective, meretricious, but to Ludovico himself they were not false. This sentimental mode is the reverse of the medal of which the obverse is the extreme emotionalism that carries Ludovico, in an opposite direction, into high dramatic violence.

That these are reconcilable expressions of a single integer of personality is made clear by Ludovico's exactly contemporaneous creation, on grandiose scale, of the *Funeral of the Virgin* (140) and the pendant *Apostles at the Tomb of Mary* (141), now in the Gallery at Parma, formerly in the choir of Piacenza Cathedral, of 1606–9. Here we are again in the realm of impassioned hyperbole, where form and idea expand to the full dimension of the space allotted to the artist: these canvases are some seven meters in height. They literally overwhelm the spectator with their magnitude, their density, and their awesome imminence. In the *Funeral* a procession of Titans, already close upon us, marches as if diagonally out into our space in twice our size. The effect on the spectator is stunning; the hyperbole is justified by its grandeur and its force of impact. In the *Apostles at the Tomb*

140.
Ludovico Carracci, *Funeral of the Virgin*.
Parma, Gallery

141.
Ludovico Carracci, *Apostles at the Tomb of Mary*.
Parma, Gallery

there is a comparable but less urgently directed power of action. Unlike the *Funeral,* this does not insist so much toward us, and it offers us release in an ascension, more than it is a recession, into a fantasy of celestial landscape.

With the *Dream of St. Catherine* in the National Gallery in Washington (142), probably of 1612, we are dealing with a painting of more normal scale, in life size. Regardless of the difference of scale, the effects of breadth of form and of authenticity of feeling are no less impressive than in the *Apostles.* These are grand forms too, richly draped, moving in diagonally ascending waves across the picture plane; the figures impinge upon the spectator and impress him with their luxury and power of presence. The expression in this painting of an emotional tonality at once resonant and fine is not more or less controlled than the eccentric sentiment of certain earlier pictures had been. Feeling here is beautifully articulate, modulating from the handsome sensuous vigor of the Virgin and the Child into the lyric loveliness of Catherine. The measure of Ludovico's sophistication in the calculated concord between forms and feelings is illustrated in the *Dream of St. Catherine* by the way in which he manipulates the rhythmic tenor of the figures and their colors to support what countenance or action illustrates of their emotions. A similar articulateness of feeling appears in the context of a dramatic narrative, the *Body of St. Sebastian Thrown into the Cloaca Maxima* (143), commissioned in 1612; the picture has recently been acquired by the Getty Museum. A high dramatic content in this painting is achieved less by any virtue of realistic description in it than by the power that is in Ludovico imaginatively to relive the scene and represent it to us in terms that seem immediate and unencumbered by convention, and to convey to us the life of his emotional response. This is an episode in which, for a moment, Ludovico's art suggests relation, though no necessary actual connection, with the recent art of Caravaggio. About the same time as the

142.
Ludovico Carracci, *Dream of St. Catherine.*
Washington, National Gallery,
Samuel H. Kress Collection

143.
Ludovico Carracci, *Body of St. Sebastian Thrown into the Cloaca Maxima.*
Malibu, Calif., J. Paul Getty Museum

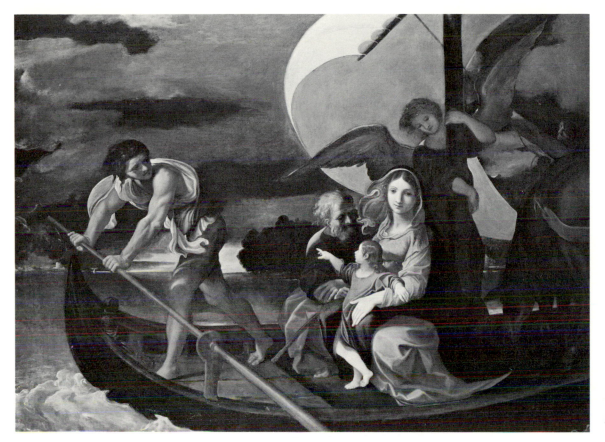

144.
Ludovico Carracci,
Flight into Egypt.
Bologna, Montebugnoli Collection

St. Sebastian, the *Flight into Egypt* (144), in the Monte-
bugnoli Collection in Bologna, demonstrates—in an op-
positely joyous tone—the same extraordinary power of
Ludovico's to relive an event in his imagination in strik-
ingly fresh-seeming terms.

We enter now into the last phase of Ludovico's career,
and though earlier happenings in his art may have prepared
us for some things that now occur, the events of this late
phase are more singular and, in instances, disquieting, than
we may have been led to expect. A first instance is the altar

in the Church of S. Francesca Romana in Ferrara (145),
dated 1614, which depicts an iconographically extraordi-
nary scene, no doubt assigned to Ludovico, which may be
described as "Christ Crucified, the Hope of Souls in Pur-
gatory." The theme itself is one to convey a sense of emo-
tional disturbance, but it seems evident that Ludovico has
treated it so as to stress the possibilities in it of eccentricity
of feeling. He has emphasized the strangenesses of type,
physiognomy, and expression; in the Christ he has insisted
on an extreme precision in the modeling of anatomy, but

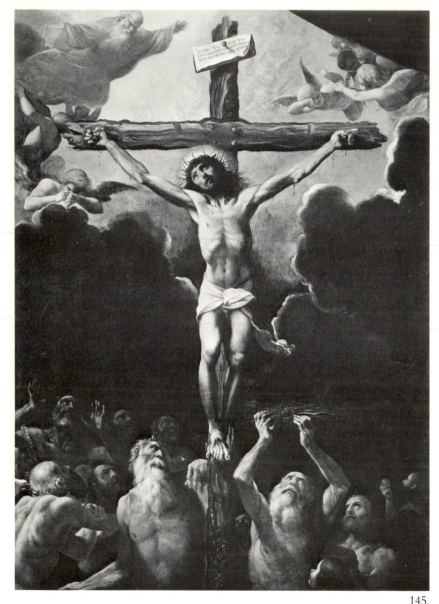

145.
Ludovico Carracci, *Christ Crucified*.
Ferrara, S. Francesca Romana

its effect, in this forcing light, becomes surreal, while the light itself, violent in its dramatic contrasts, is manipulated to create an abstracting and heraldic pattern. This is an emotionally aberrant and disquieting image with an overtone of gloom and a flavor of morbidity. The emotionally eccentric temper that is always immanent in Ludovico, which appeared in its acutest form about 1607, has surfaced once again in a depressed key and in a work of monumental size.

A year or two later than the *Crucifixion* in Ferrara, the *S. Carlo Borrommeo Administering the Eucharist* (146), in the Abbey at Nonantola, is a much more melancholy work. Again, light is a primary agent to convey emotion, but here the force of light is considerably diminished and the darknesses corrode the forms. Even the sole strong field of color, S. Carlo's robe, makes a melancholy effect within this context. In form and in quality of expression this is a literally morbid mode, both in the English sense of the word and in the Italian one, which can convey the sense of an excessive softness.

The *Adoration of the Kings* (147) in the Brera in Milan, signed and dated 1616, is representative of the group of paintings in this late mode—the morbid mode—developed to its extreme degree. A crepuscular light finds out the protagonists but reveals as it does so how pliable and substanceless they are; in the half-darkness the secondary actors are almost wraithlike, strange-featured, in places caricatures. The expressive matter of the entire picture is as pliant and corroded as the form. It is sentimentality in a black vein, as humor can be black.

Though this morbid vein is the dominant one of Ludovico's last years, and though it intrudes its tenor into almost all he does from around 1613 or 1614 to his death in 1619, it does not wholly consume Ludovico's genius for inventing unconventional and emotion-generating images, particularly of a narrative or dramatic kind. Take, for ex-

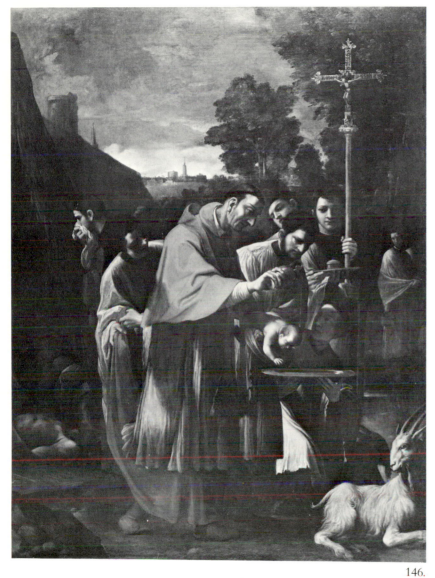

146.
Ludovico Carracci, *S. Carlo Borrommeo
Administering the Eucharist.* Nonantola, Abbey Church

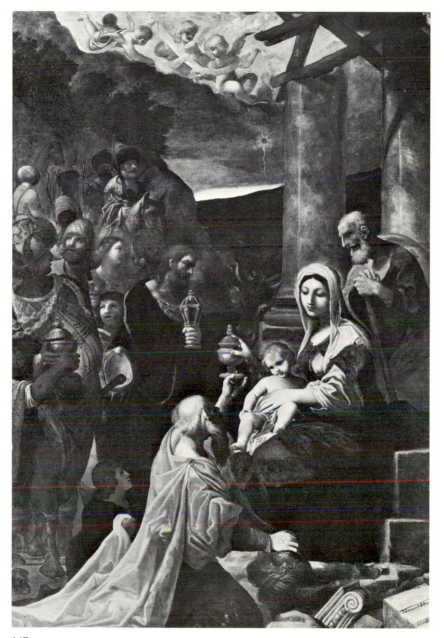

147.
Ludovico Carracci, *Adoration of the Kings.*
Milan, Brera Gallery

[111]

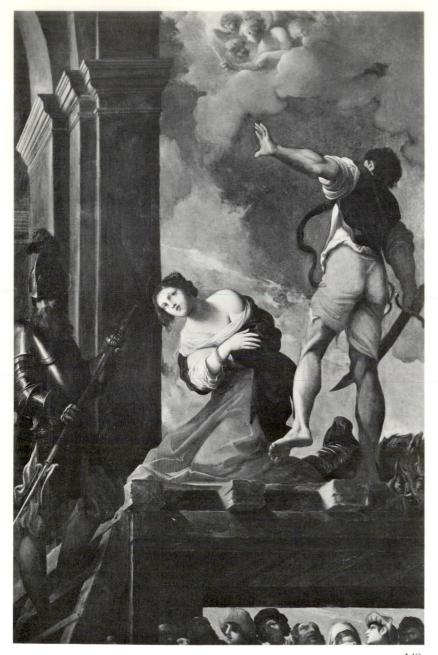

148.
Ludovico Carracci, *Martyrdom of St. Margaret*.
Mantua, S. Maurizio

149.
Ludovico Carracci, *St. George and St. Catherine
Led to Martyrdom*. Reggio Emilia, Church of the Ghiara

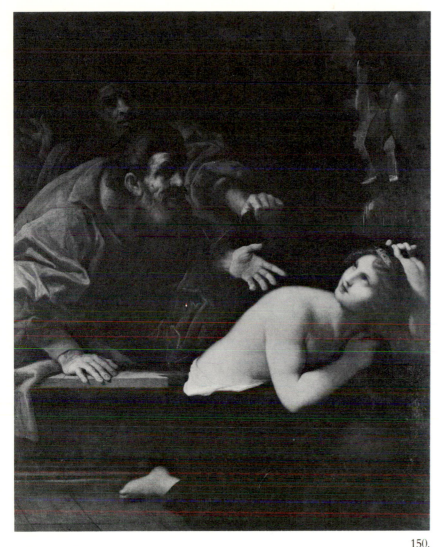

Ludovico Carracci, *Susanna and the Elders*. London, National Gallery

ample, the *Martyrdom of St. Margaret* (148) in the Church of S. Maurizio in Mantua, of 1616, with its brilliant manipulation of perspective devices and of stagelike setting that compel connection with the spectator, and the conjunction in the picture—typically Baroque—of sensuality with violence. Altogether like a piece of theatre in its staging is the *St. George and St. Catherine Led to Martyrdom* (149) in the Church of the Ghiara in Reggio Emilia, finished in 1618. It is compelling and immediate in its narrative, of which the tragic and suspenseful sense is supported by the crepitation in the background Ludovico makes with light. Yet all his effectiveness of dramatic device is deflected toward emotional eccentricity by the mannered—indeed Maniera—shaping of the forms and by the sentimental artificiality conveyed in their expression.

The *Susanna and the Elders* of 1616 (150) is a theme that seems appropriately to claim the attention of an aging artist (Ludovico was now sixty-one)—the theme of the power and beauty of the female being and her desirability. Ludovico makes Susanna's body live in light, yet the radiance he pours on her makes an equivocation in her flesh with smoothed marble, and Susanna's head, doll-pretty, at the same time has the artificial beauty of a piece of classic statuary. There are a largeness of form and a grandeur of idea that, in the middle of Ludovico's latest, morbid, mode evoke the kind and merit of his works of a prior time.

Ludovico's genius was always particularly summoned by the challenge of grand scale, and in his last major work, the fresco *Annunciation* in the Cathedral of S. Pietro in Bologna (151), finished in 1619, Ludovico made a last great exercise of his inventive narrative imagination. Two great forms in a relation that magnifies their scale and the implication of a movement in between them arch toward each other across a light-filled space; we are made to feel the separate grandeur of each actor and, in the same instant, the tension that connects them. This last work of Ludo-

[113]

151.
Ludovico Carracci, *Annunciation*. Bologna, S. Pietro

vico's is to us an affirmation of his undiminished powers of invention and confirms the stature of his accomplishment in his long career. Yet the *Annunciation* was criticized for a detail—an alleged misdrawn foot—and legend has it that Ludovico died in 1619 of chagrin at the painting's hostile reception. But the problem could not have been just a matter of detail; the great merits he continued to display, even in the context of the eccentric, morbid mode of his later years, were in historical fact by now old-fashioned in their mode of form and their character of expression. His own past pupils in Bologna, as well as those who had gone from him to work with his cousin Annibale in Rome, had passed Ludovico by in their pursuit of a new reach of the modern style he had helped to found.

Bibliography

Credits

Index

Bibliography

This short bibliography is restricted to writings in English.

CARAVAGGIO

Friedlaender, W. *Caravaggio Studies*. Princeton, N.J., 1955; paperback ed., New York, 1969.

Hinks, R. *Michelangelo Merisi da Caravaggio*. London, 1953.

Posner, D. "Caravaggio's Homoerotic Early Works." *Art Quarterly* 34 (1971), 301–324.

THE CARRACCI

Bellori, G. P. *The Lives of Annibale and Agostino Carracci* (translated by C. Enggass). University Park and London, 1968.

Boschloo, A. *Annibale Carracci in Bologna: Visible Reality in Art After the Council of Trent* (translated by R. Symonds). The Hague, 1974.

Dempsey, C. "'Et Nos Cedamus Amori': Observations on the Farnese Gallery." *Art Bulletin* 50 (1968), 363–374.

Dempsey, C. *Annibale Carracci and the Beginnings of Baroque Style*. Glückstadt, 1977.

Martin, J. *The Farnese Gallery*. Princeton, N.J., 1965.

Ostrow, S. *Agostino Carracci*. Ann Arbor, Mich., 1972.

Posner, D. *Annibale Carracci: A Study in the Reform of Italian Painting Around 1590*. London and New York, 1971.

Credits

For a figure not listed below, it may be assumed that the photograph used for reproduction has been supplied directly by the public museum or gallery to which the painting belongs.

Agraci: 92

Alinari: 16, 28, 39, 40, 43, 45, 49, 51, 61, 66, 72, 76, 77, 83, 88, 93, 96, 99, 100, 103, 105, 106, 109, 110, 114, 123, 124, 132

Anderson: 18, 25, 31, 32, 36, 53, 54, 62, 70, 78, 80, 81, 82, 95

Archivio Fotografico, Soprintendenza for Parma and Piacenza: 140, 141

Böhm: 33

Brogi: 1, 9, 58

Bruckmann: 30, 34

Courtauld Institute of Art: 138

Credito Romagnolo, Bologna; from C. Volpe, *Il fregio . . . e i dipinti di Palazzo Magnani:* 118

Croci: 7, 151

Cuming Associates: 120

Fotofast: 4, 129, 146

Fototeca Unione: plate II

Gabinetto Fotografico Nazionale, Rome: 2, 8, 111

Gernsheim: 71

Giraudon: 91

Hanover Studios, London: 14

Istituto Centrale per il catalogo e la documentazione, Rome: 56, 59, 60, 63, 89

Istituto Centrale del Restauro, Rome: 101, 102, 104

L. von Matt: 67

Photo Studios: 23

Rizzoli: plate I

Scodé: plate III

Sommer: 52

Villani: 5, 6, 12, 13, 15, 17, 19, 20, 21, 22, 24, 27, 35, 37, 41, 48, 107, 112, 116, 117, 119, 125, 126, 127, 130, 131, 133, 134, 135, 136, 137, 139, 144, 145, 147, 148, 149

source untraceable: 10, 75, 87, 122, 128

Index

Numbers in italics refer to pages with illustrations.